DISCOVER YOUR WORLD
IN PEN, INK & WATERCOLOR

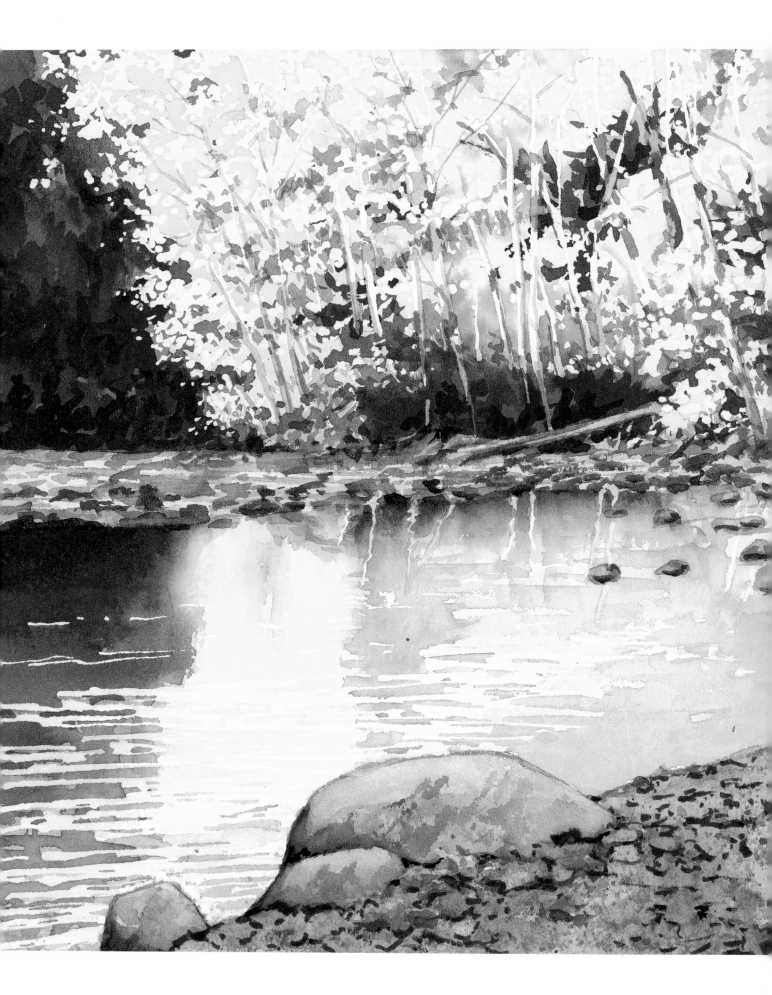

Discover
Your World
in pen, ink
& watercolor

Claudia Nice

NORTH LIGHT BOOKS
CINCINNATI, OHIO
artistsnetwork.com

Contents

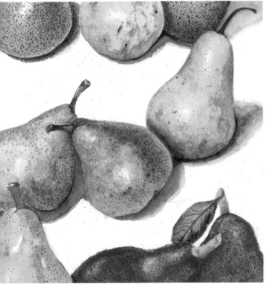

Getting Started

If I were to compare creating a watercolor painting to baking a cake from scratch, then this introduction would be the list of ingredients and general information needed to get started. If you are an experienced cook (artist), you may already have the necessary tools and ingredients on hand and know how to use them. Nonetheless, reviewing is good. You never know what new tool or updated idea may be tucked away among the tried and true tools and methods. If you are just beginning, then study these techniques carefully to gain some of the basics that you will use over and over again.

Just as the creation of a cake begins by placing the ingredients in a bowl and stirring them together, creating a watercolor painting begins with the initial application of pencil or paint to the paper. Once the paper has been marked, you are somewhat committed to the project. How you proceed is up to you. The cook may stir the ingredients together by hand, slowly, with great care, or they might be blended quick and easy with a mixer. In the following chapters, I will show you how to begin slow and easy by pencilling in the design and laying down pale washes in each area to mark or map out the total composition. There will also be some examples of jumping right in with courageous colors, stouthearted values and bold brushstrokes, moving the painting forward in a spontaneous, carefree manner. No matter how the cook accomplishes it, the initial blending process will result in gooey liquid batter that is far removed from what the cake will hopefully look like in the end. The artist also will reach the batter stage, where the painting looks like a jumble of shapes and colors and falls far short of the goal seen in the mind's eye. This is the ugly stage. Don't give up; all creations go through it before reaching completion. The cook puts the batter in the pan and proceeds to bake it. You, as the artist, need to bravely stride forward through the batter stage and find the joy in seeing the painting take shape.

The baker finishes the cake by applying frosting. Paintings are completed by adding the small details and defining touches. The darkest shadows and vibrant accents are added, and missing white highlights are razor-scraped into place. When this is done the watercolor painting can stand completed or, just as the baker may add some decoration to the frosting, the artist may choose to enhance the painting with some pen-and-ink texturing. A portion of this instruction book is dedicated to showing you how, when and where to add pen-and-ink enhancements to make your cake a successful and unique creation that you can take pride in.

Tools and Materials

This is a list of the main art materials used to complete the paintings and demonstrations seen in this book. However, new materials are constantly appearing in the catalogs and art stores, while old favorites are sometimes discontinued. Use this list as a general guide and update your art supplies according to what's available. Don't be afraid to experiment.

PENS

The ideal pen has a steady, leak-free flow and a precise nib that can be stroked in all directions.

- Technical pens (such as Koh-I-Noor's Rapidograph in sizes .25 or .30, .35 and .50)
- Permanent fiber tip pens (such as Pigma Micron 005 and 05 or Faber-Castell Pitt artist pens in sizes Superfine, Fine and Brush in both black and brown ink colors)
- Crow quill dip pens nos.102 and 104

INKS

For mixed-media work, choose an ink that is lightfast, compatible with the pen you are using and brush-proof, withstanding vigorous overlay applications of wet washes without bleeding.

- Black ink—Select brush-proof India ink such as Koh-I-Noor's Universal Black India 3090
- Brown ink—Brown, Burnt Umber, Burnt Sienna or Sepia are all good shades
- Colored inks—Choose lightfast, permanent inks that can be brushed over with watercolor washes. I recommend Daler Rowney FW Artistss Acrylic ink.

WATERCOLOR PAPER

Choose a good quality, 140-lb. (300gsm) cold-pressed watercolor paper. I prefer Arches or Winsor & Newton Artists' brand. Avoid student-grade paper. Taping the edges of the paper to a wood or plastic backing board will help the surface retain its shape and still allow you to rotate it to accommodate pen-and-ink stroke work.

BRUSHES

The best brushes to use with watercolor are sable or sable blend, which hold large quantities of water and retain their shape while stroking. A basic starting set should include a no. 4 and 8 round brush, a ¼-inch (6mm) and ½-inch (12mm) flat or long (bright) brush and an old, scruffy synthetic flat brush for stippling. Working in larger formats than 9" × 12" (23cm × 30cm) will require larger-sized brushes.

MASKING FLUID

There are a wide variety of masking fluids and applicators to choose from with constant product updates. At present, I am partial to the Daniel Smith Artist Masking Fluid with its replaceable/adjustable application tubes.

PALETTE

You will need a white plastic palette or a white dinner plate to mix your paint on.

WATERCOLOR PAINTS

Choose six basic primary colors to get started. The paints used in this book are M. Graham (the first color listed in each line below, followed by equivalent color choices).

- Warm yellow—Gamboge, New Gamboge or Cadmium Yellow Medium
- Cool yellow—Azo Yellow, Lemon Yellow, Winsor Lemon or Cadmium Yellow Pale
- Warm red—Cadmium Red Light or Cadmium Scarlet
- Cool red—Quinacridone Rose or Permanent Carmine
- Warm blue—Ultramarine Blue or French Ultramarine
- Cool blue—Phthalocyanine Blue or Winsor Blue (Green Shade)

Other tube colors I use include Azo or Cadmium Orange, Dioxazine Purple, Permanent Green, Sap Green, Burnt Sienna, Sepia and Payne's Gray.

OTHER USEFUL TOOLS

Other materials you might find useful (including everyday household objects): backing board, camera, drinking straw, facial tissue, masking tape, paper towels, permanent markers, razor scraper, sand, straight-edge and a water bottle with sprayer.

Basic Color Mixing

The primary hues are red, yellow and blue. From these three colors, in their purest state, all other colors can be mixed, the exceptions being black and white. Red is the strongest primary hue. Mixtures containing a noticeable amount of red are considered warm. Yellow is also considered warm, but to a lesser degree than red. Blue is a cool color.

The secondary colors are orange, green and purple and are produced by mixing two primary colors together. However, it is hard to find an absolutely pure primary red, blue and yellow from which to mix vivid secondary hues. For instance, a paint labeled *yellow* may contain a hint of red making it warm. It will work well to mix oranges, but will produce muted, olive greens.

The solution is to use six primary mixings colors, a warm and cool representative for each primary hue, and combine them as shown in the color wheel chart below. To produce a medial red, yellow or blue, simply mix the warm and cool representatives together.

Tertiary colors, the color mixtures produced by mixing a primary color with its corresponding secondary color, include a range of yellow-oranges, red-oranges, red-violets, blue-violets, blue-greens and yellow-greens.

Complementary colors are those located opposite each other on the color wheel. Violet complements yellow, green complements red, and orange complements blue. Mixing complementary colors together will produce rich browns and grays.

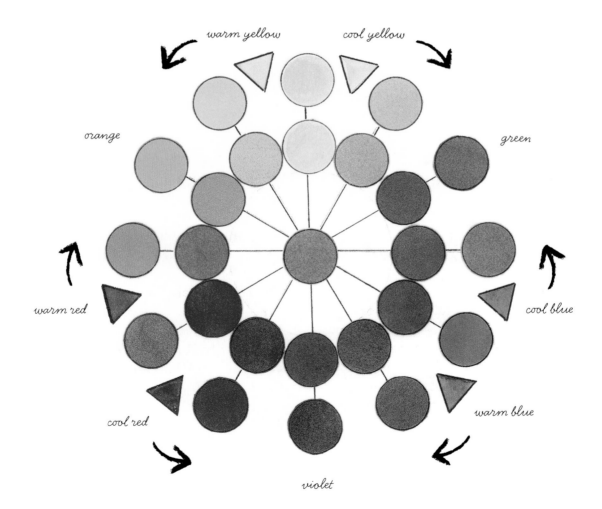

warm yellow cool yellow

orange green

warm red cool blue

cool red warm blue

violet

Color Mixing Guide Using Six Primary Hues

Warm Blues
Ultramarine Blue
French Ultramarine

Cool Blues
Phthalocyanine Blue
Winsor Blue (Green Shade)

Pastels
(thinned with water)

Base Colors

Shadows, Browns and Grays
(mixture of base color plus its complement)

Pastels	Base Colors	Shadows, Browns and Grays
chartreuse	cool yellow plus green yellow-green	plus varied amounts of red-violet
light green	cool yellow plus cool blue green	plus varied amounts of red
aqua	green plus cool blue blue green	plus varied amounts of red-orange
baby blue	cool blue plus warm blue blue	plus varied amounts of orange
lavender	warm blue plus violet blue violet	plus varied amounts of yellow-orange
orchid	warm blue plus cool red violet	plus varied amounts of yellow

8

<u>Cool Yellows</u>
Azo Yellow
Cadmium Yellow
Light or Pale
Cadmium Lemon
Winsor Lemon

<u>Warm Yellows</u>
Gamboge
Cadmium Yellow Medium
New Gamboge

<u>Warm Reds</u>
Cadmium Red Light
Cadmium Scarlet

<u>Cool Reds</u>
Quinacridone Rose
Permanent Carmine

<u>Shadows, Browns and Grays</u>
(mixture of base color plus its complement)

<u>Base Colors</u>

<u>Pastels</u>
(thinned with water)

varied amounts yellow-green of added to

cool red
plus violet

red-violet

light rose

varied amounts of green added to

cool red
plus warm red

red

pink

varied amounts of blue-green added to

warm red
plus orange

red-orange

coral

varied amounts of blue added to

warm yellow
plus warm red

orange

peach

varied amounts of blue-violet added to

warm yellow
plus orange

yellow-orange

pale saffron

varied amounts of violet added to

yellow

warm yellow
plus cool yellow

butter
(light yellow)

9

Basic Pen Strokes

Two kinds of marks can be created with a pen: dots and lines. Lines can be quite varied in appearance. They can be long, short, straight, curved, looped or laid across each other. The basic stroking techniques shown here will get you started.

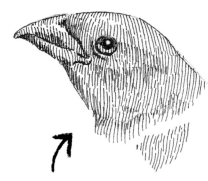

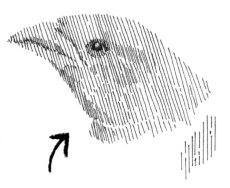

Contour lines work well to depict smooth, rounded objects.

Parallel lines give a subject a flat, smooth appearance. They also can be used to portray distance or haziness.

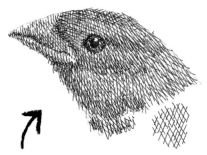

Crosshatching can produce a wide range of textures ranging from semi-smooth to very rough, depending on the nib size, the angle of the lines and the precision of the strokes.

Stippling or dots work well to depict a surface composed of numerous small particles.

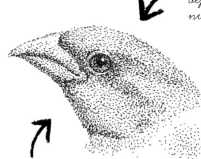

Fine dots lend a dusty, antique quality to the subject.

Scribble lines create a thick, matted look that works well to portray foliage, curly hair and tangled textures. They complement loose brushstrokes.

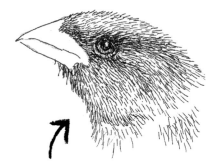

Crisscross lines provide a grass-like or hair-like appearance.

Wavy lines are useful for depicting repetitive grainy patterns such as those found in wood.

Brushstrokes and Techniques

The type and size of the brush you choose to use and the dryness or wetness of the surface to which it is applied will go a long way in determining the result.

DRY SURFACE

When a loaded brush is stroked over a dry paper surface, the liquid paint is absorbed readily into the paper fibers, resulting in lines or wash areas with crisp, hard edges.

DRY-BRUSH

When a well-blotted brush is stroked over a dry surface, it will skip across the raised areas of the paper, creating a rough, partially painted appearance.

WET-INTO-WET

A fully loaded brush applied to a wet, shiny but not runny paper surface will free-flow in the moist areas. The results are soft edges, spontaneous color mixtures and a lightening of the color as the pigment spreads out.

DAMP SURFACE

A damp surface is one that has been liberally moistened, then blotted to remove the wet sheen on the surface. The applied paint is absorbed into the paper at a slower rate allowing the strokes and wash areas to be easily blotted, blended, bruised or altered in some other manner. Damp surface strokes often have semi-soft edges.

11

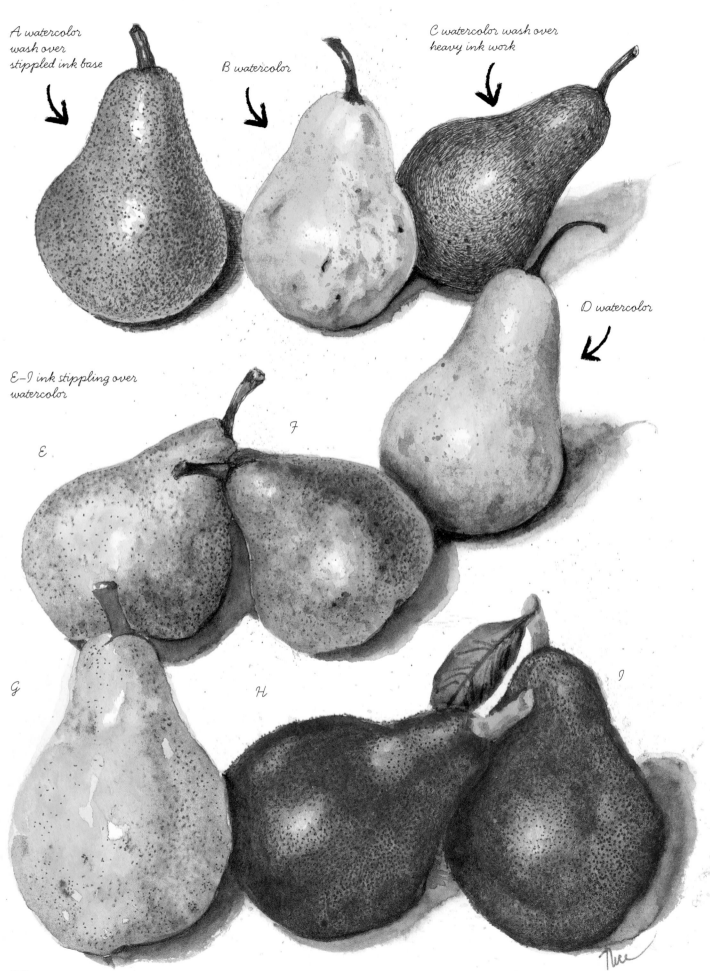

A watercolor wash over stippled ink base

B watercolor

C watercolor wash over heavy ink work

D watercolor

E-I ink stippling over watercolor

E

F

G

H

I

12

Pen, Ink and Watercolor Techniques

I have always favored pen and ink as a medium. Pen-and-ink lines are bold, marking the paper with fortitude. While broken ink lines can suggest lost edges and highlighted areas, each small mark stands in stalwart contrast against the paper, for there is no greater contrast than black against white. Brown ink against white is more subtle, so for some of the work on the pages of this book I have filled my pen with the warmer shades of sienna, umber or sepia. In addition to providing a bold statement, pen strokes can create wonderful faux textures ranging from smooth and contoured to gritty, grainy and roughly weathered. When the beautiful hues and the transparency of watercolor are combined with the lionhearted qualities of pen and ink, the artistic possibilities are endless.

Consider these painted pears. A and C were inked first and then washed with watercolor. Stroking the ink lines on first marks the work as a drawing rather than a painting. Due to the bold nature of ink lines, delicate objects may take on a stiff or overdefined appearance. Pear A, marked liberally with Burnt Sienna stipple marks, looks pitted rather than speckled, while pear C, stroked with heavy contour lines and stippling in darker shades of brown, looks rough and wooden.

In contrast, notice how delicate the skin on pears B and D appears. They were painstakingly painted with glazed washes of watercolor and a bit of spatter. They look great, but the technique takes time to develop and lots of practice. There is an easier way to get a similar effect.

Pears E through I were painted using wet-into-wet techniques or simple layering/blending applications, and a touch of ink texturing, in this case stippling. The result is colorful, luminous and textured just enough to look edible. This combination of watercolor overlaid with pen and ink is the technique that will be passed along to you on the pages of this book. The ink work may be subtle and discreet or bold and flamboyant depending on the subject matter.

Just for fun I will also be introducing some simplified impressionistic watercolor techniques for those who like to express themselves in loose, relaxed brushstrokes, noted in examples J and K.

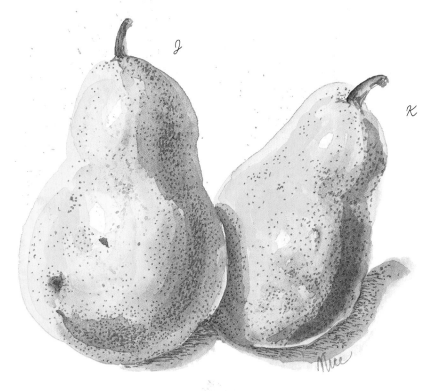

J–K loose, impressionistic technique with relaxed brushstrokes

Field Studies

Put on your outdoor walking shoes and stroll down a country lane. Linger under the overhanging boughs of an ancient maple, oak or cottonwood tree. Look up and see how the light plays in the branches. Now open that old wooden gate and step into the field beyond. Hear the swish of the grass as you pass by and note the variety of greens, browns and ochres that surround you. Raise your sights to the distant pasture and the rolling hills sitting on the horizon. See how subdued the shapes and colors become as the background fades into the sky. Breathe deep, the air is fresh and sweet, and artistic inspiration is as abundant as the birds and pollen-laden bees.

This chapter focuses on rural scenery. Consider *Dahlia Farm.* The blossoms are strikingly vivid, but it is the contrast of the plain, white farmhouse that draws the eye into the landscape. Patches of black pen work in the foreground boldly accentuate the flowers and foliage, giving them a faux block-print effect.

Dahlia Farm
Watercolor with ink enhancement
15" × 11" (38cm × 28cm)

Pen Techniques

Before exploring the projects in this chapter, you will want to become familiar with bruising, spatter and pen blending techniques.

pen blending

brown pen work

drybrushing

base wash of Sap Green + Burnt Sienna

bruising

unpainted areas

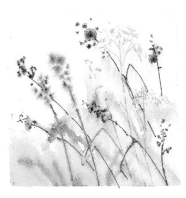

bruising

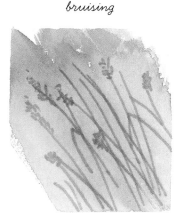

moist surface *spatter* *dry surface*

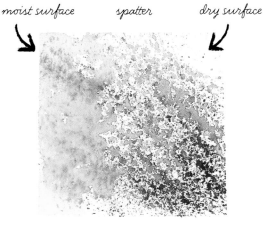

pen blending

Bruising occurs when a narrow, blunt tool like a stylus or toothpick is dragged through a freshly laid wash, leaving a grooved depression that quickly fills with a gathering of pigment. The result is a darkened line.

Spatter is the technique of flicking a fully loaded brush against a fingertip or the edge of a credit card to create a random pattern of paint droplets. Spatter that lands on a moist surface will spread out and lighten. Dry-surface spatter will retain its gritty appearance.

Pen blending is a spontaneous flaring and softening of an ink line when it is applied over a moist surface. Technical pens work best for this, although stroking a freshly laid fiber-tip ink line with a moist brush will cause it to bleed.

Wild Grasses

Tall, uncut field grass mingled with weeds is a common sight when painting in the field. Its unruly appearance can add both color and texture to the country landscape or become a nice study all by itself.

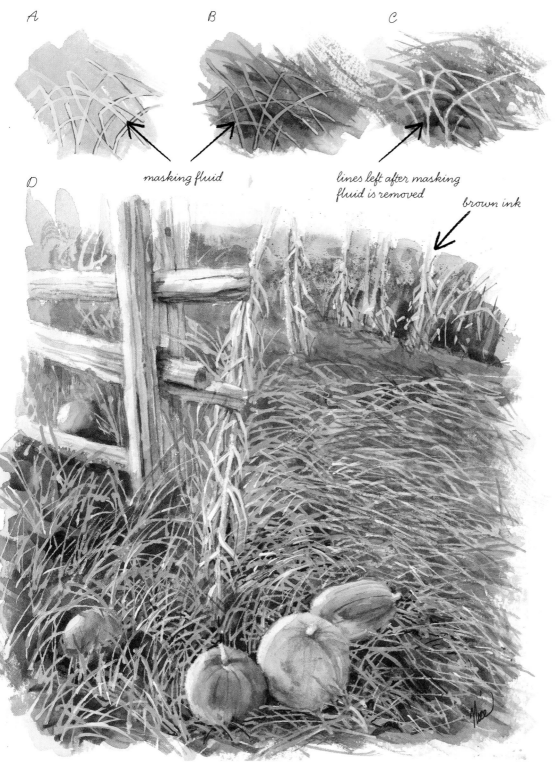

A

B

C

masking fluid

lines left after masking fluid is removed

brown ink

D

In this garden scene, the grass is overgrown and weathered. Morning frost glints blue and cold in the pumpkin patch. Here are the steps I took to paint it.

Step 1: A pale base wash of green mingled with patches of medial blue was applied to the grass area and left to dry.. Abundant "grass blade lines" were drawn over the wash with masking fluid.

Step 2: Additional washes of green and blue were applied over the base wash using both flat-wash and dry-brush techniques.

Step 3: When thoroughly dry, the masking fluid was removed by rubbing it with the sticky side of masking tape, revealing the lighter grass blades.

Step 4: In the finished scene, some of the grass stems were tinted slightly darker, while others were highlighted by razorblade scrapes or fine lines of white acrylic. Brown ink lines were added sparingly to the cornstalks, and black ink was applied here and there in the deep shadows of the grass.

Weathered Wooden Fences

Fences are perfect for adding a bit of height and a sense of rhythm to a pasture scene. To obtain rich weathered-wood browns and grays, try mixing Ultramarine Blue with orange. The more orange added to the mix, the warmer the hue becomes.

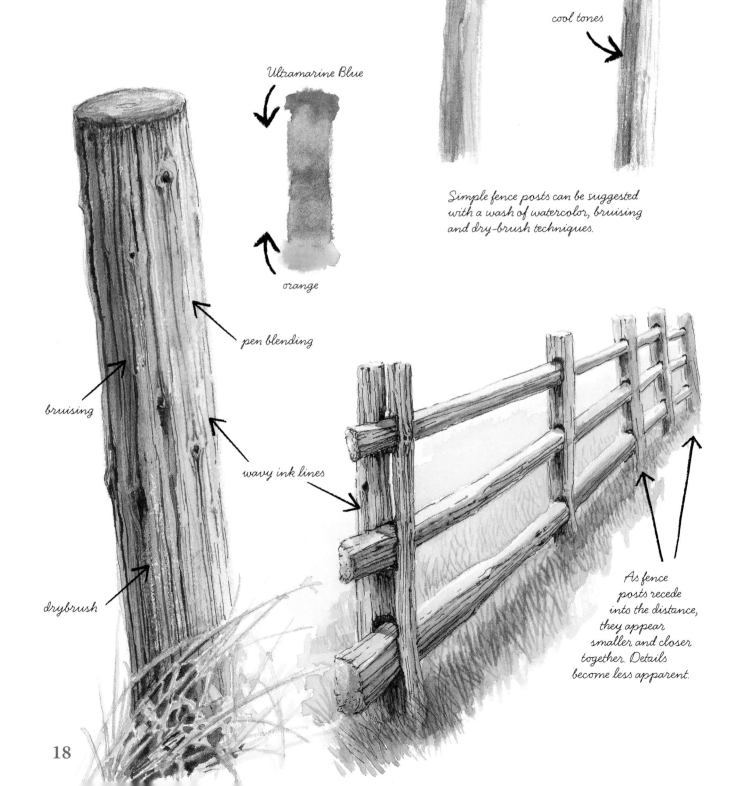

warm tones

cool tones

Ultramarine Blue

orange

Simple fence posts can be suggested with a wash of watercolor, bruising and dry-brush techniques.

pen blending

bruising

wavy ink lines

drybrush

As fence posts recede into the distance, they appear smaller and closer together. Details become less apparent.

White fences or those that are strongly highlighted can be left unpainted. The background colors will give them definition. The watercolor studies on this page were painted loosely in layered washes, working from the lightest to the darkest, and allowing each layer to dry in between. The foreground of each painting was textured with pen and ink. Scribble lines were used to accentuate the iris patch, and brown crisscross lines help suggest the dry grass in the lower painting. Bruise lines were used to texture the green grass areas.

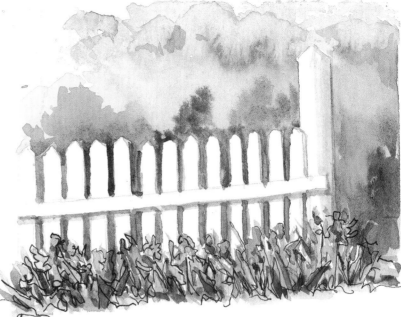

Using broken ink lines will give wire fencing a light, flexible appearance.

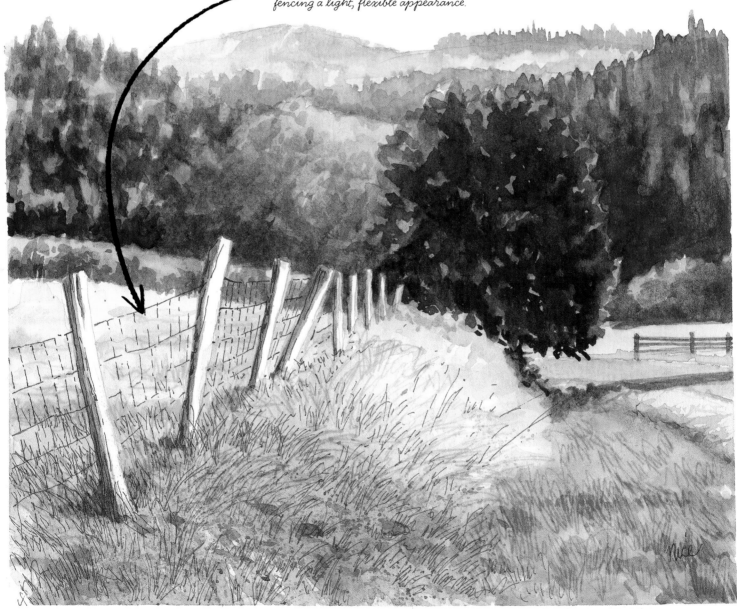

Rocks and Fieldstones

Most rocks have lumpy, abstract shapes. As you can see in step one, an earthy wash of color doesn't really define them. To turn lumps into rocks you need light play (shadows and light areas). To create rocks with surface character, you need to add texture.

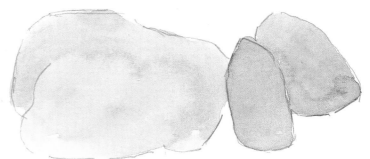

Step 1: Draw a grouping of blunt-bottomed lumps and fill them in with a wash of color in an earthy hue. I used a warm yellow-purple mixture for the large ochre rock and a cool red + yellowish green mixture for the maroon ones. Don't overblend the mixtures. Allow for some variation in hue.

blended edges

hard edge

Step 2: Use a small flat brush to layer on darker shadow mixtures. Gradual, blended value changes suggest rounded curves, while hard edges denote an abrupt angle change on the surface of the rock.

Step 3: Add texture to the surface of the stone using drybrush, spatter, pen-and-ink marks and pen blending. I used both black and brown inks.

On these rocks I applied a minimal amount of painted shadows and lots of loosely scribbled pen-and-ink lines to give them a sketchy appearance. This quick, carefree style is great for creating sketchbook journal entries.

Paint a Rock Scene

Walking along a country road at the edge of a pine forest, I came across a stalwart tree struggling to grow between two large boulders. Its trunk carried a great scar where it had pushed into the rock. However, it seemed to be winning the battle, as one of the boulders had been split apart by the constant pressure. I couldn't resist capturing the scene.

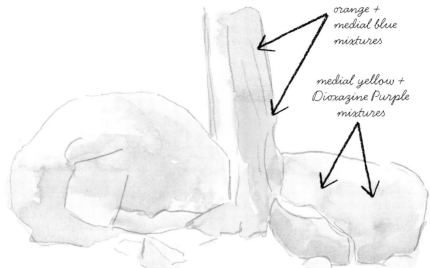

orange + medial blue mixtures

medial yellow + Dioxazine Purple mixtures

Step 1: Pencil in the basic shapes and lay down a light watercolor wash for the basecoat using the color mixtures above. Note that more than one variety of each mixture was applied.

blended edges

hard edges

Step 2: Paint in the shadow areas using darker versions of the color mixtures used previously. Sepia was used to fill in the deep shadows beneath the boulders.

Step 3: Further definition and texture was added to the scene by applying a bit of spatter, scribbled ink lines and pen blending. Burnt Sienna was used to brighten the rocks, and the plants and bushes were painted in mixtures of green and yellow-green muted with Burnt Sienna.

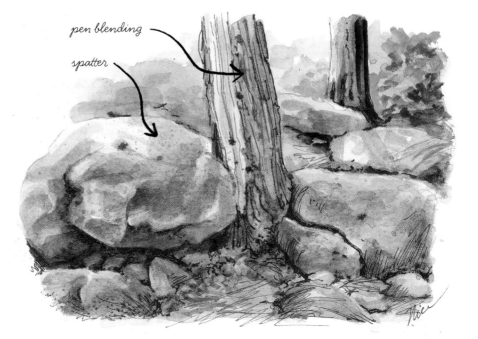

pen blending

spatter

Green Rolling Hills

Like a green patchwork quilt, the fields and pastures entwine at intriguing angles, one rising above another until they fade into the distance. In order to maintain color harmony in the scenes, I chose one base color (Sap Green) and mixed all the other greens from it.

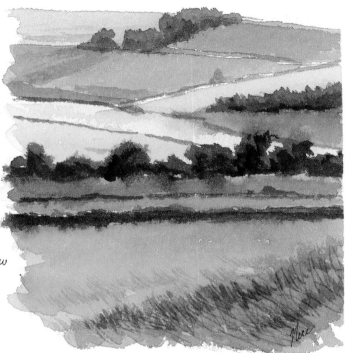

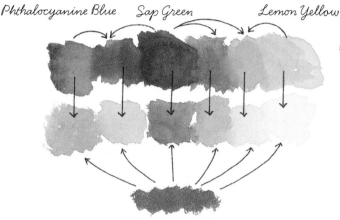

Phthalocyanine Blue *Sap Green* *Lemon Yellow*

Cadmium Red Light

A hint of red added to each green hue will provide grays and shadow colors.

These two-step mini-paintings began with light washes in each color area. After the basecoat was dry, a second layer was applied as needed to create shadows or intensify the color. Because these are distant landscapes, I felt that pen-and-ink work would be too prominent and distracting. Instead, I used bruising to texture the grass blades.

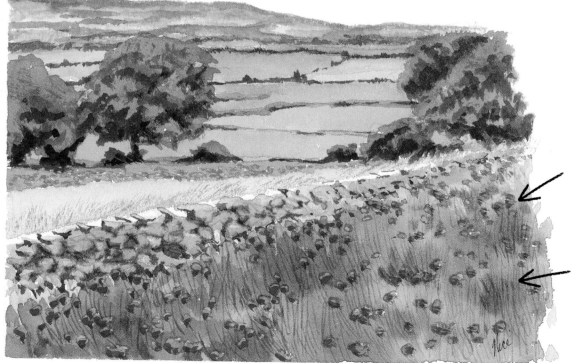

White spaces for the poppies were masked out while the grass was painted, then the red blossoms were filled in last.

bruising

Stone Masonry

Pen-and-ink detailing really brings out the texture on a rock wall seen up close. Compare example A to B in the masonry study. In example A, preliminary washes mixed from complementary colors were applied to suggest rock shapes and moss and the paler mortar in between. Shadows were loosely painted over the dry stone shapes to give them form. In example B, the shadows, cracks and angles in the rocks were accentuated with pen blending.

A B

black ink lines applied to a surface

spatter

Brown ink crisscross lines add interest to the grassy foreground.

The strong horizontal shape and the curving arches of the stone bridge create an eye-catching center of interest in the pastoral landscape. However, it's too distant to detail the individual rocks in the masonry with pen and ink. Loosely bruising in a few lines and shadows is sufficient.

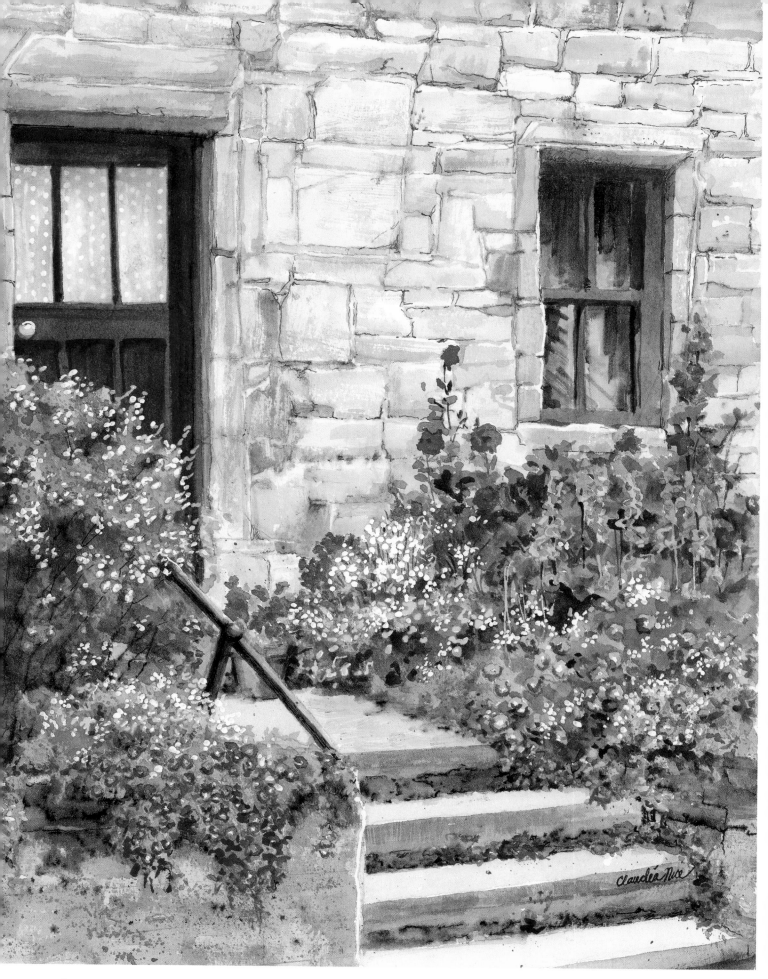

The masonry was textured with pen blending using brown and black inks.

Stair-Step Garden
Watercolor, white acrylic and pen and ink
12" × 9½" (30cm × 24cm)

Perennial Gardens

The old-fashioned perennial garden has a carefree nature, its hardy members spreading and reseeding themselves where they will. It's the lack of symmetry, along with an abundance of color and texture, that makes them especially appealing to the artist. To paint the lush entanglement of foliage and flowers, begin by breaking it down into workable components. In *Stair-Step Garden*, the flower spaces were protected with masking while the foliage areas were painted in loosely applied layers, starting with the lightest greens. The masking was then removed and the blossoms filled in. Dots of white acrylic paint were used to add the delicate sprays of baby's breath.

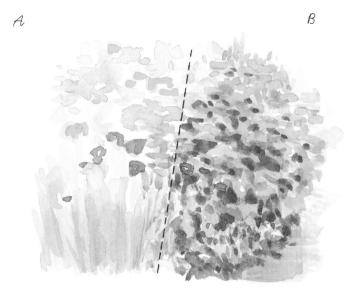

This painting began by mapping out the flowers and the palest leaf groupings with daubs of pastel watercolor (A).

When the base layer was dry, the midtones and shadows were applied to pop out the lighter areas (B). Loosely scribbled ink lines add texture and depth to the scene (C).

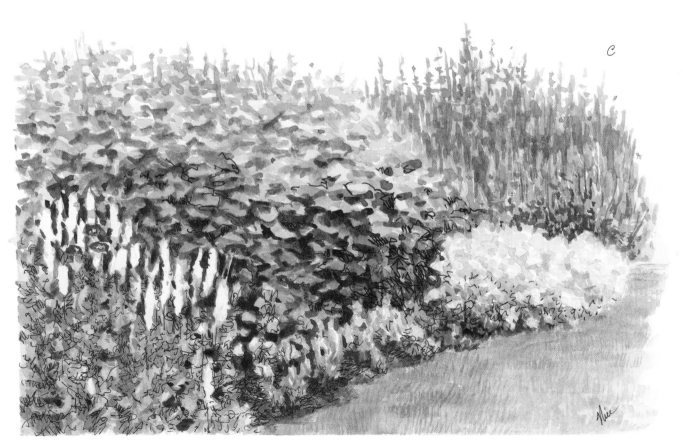

Creative Trees

Since trees grow in a spontaneous manner, sculpted by the whims of nature, you can feel free to let your imagination run wild while painting them. Here is a fun, slightly unpredictable technique to get you started . . . straw-blown ink.

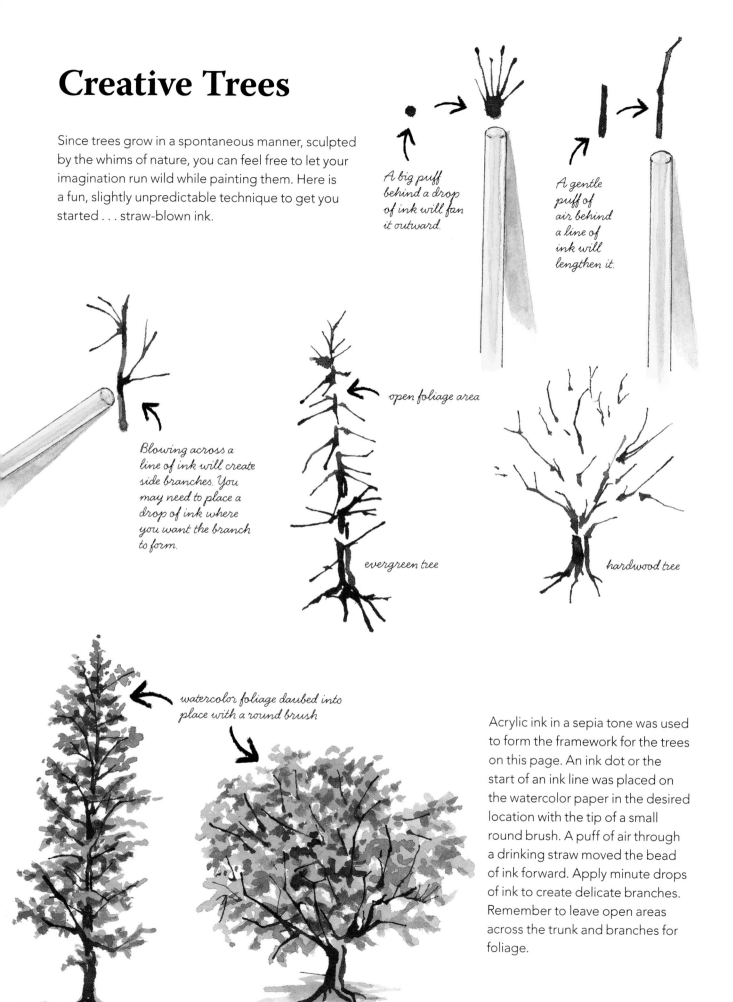

A big puff behind a drop of ink will fan it outward.

A gentle puff of air behind a line of ink will lengthen it.

Blowing across a line of ink will create side branches. You may need to place a drop of ink where you want the branch to form.

open foliage area

evergreen tree

hardwood tree

watercolor foliage daubed into place with a round brush

Acrylic ink in a sepia tone was used to form the framework for the trees on this page. An ink dot or the start of an ink line was placed on the watercolor paper in the desired location with the tip of a small round brush. A puff of air through a drinking straw moved the bead of ink forward. Apply minute drops of ink to create delicate branches. Remember to leave open areas across the trunk and branches for foliage.

Paint a Leafy Tree

To paint a leafy shade tree or fruit tree, begin with a simple pencil drawing to indicate the basic shape of the trunk, limbs and crown.

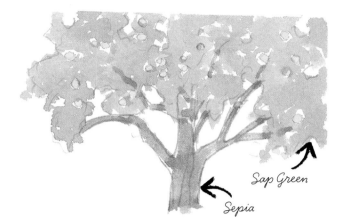

Sap Green

Sepia

Step 1: Use light-value watercolor washes to fill in the various parts of the tree. If the tree has blossoms or fruit, paint them in first, followed by the leaf clusters, trunk and limbs.

Step 2: Darken the green by adding a little Payne's Gray and daub in some shadow areas with the tip of a no. 4 round brush. Use two or more value mixtures to give the foliage the illusion of depth. Mix a stronger wash of Sepia to shade the trunk.

Step 3: Texture the leaf clusters using a .25 or .35mm pen nib and loose, loopy scribble lines.

Roads and Pathways

A country road meandering out of sight can add intrigue to your rural landscape. Keep in mind that a curved lane is more artistically pleasing than a road that runs straight through your painting.

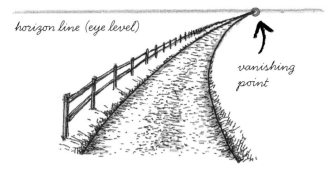

horizon line (eye level)

vanishing point

To create the illusion of proper perspective, the road should appear narrower as it recedes into the distance until it disappears altogether at some point along the horizon line... or it may simply curve out of sight, mid-painting, behind a ridge or clump of trees.

Shadows and fallen leaves can add interest to dull asphalt road surfaces. The asphalt gray is a blue-orange mixture.

scribbled pen lines (.25mm) in brown and black inks

A distant figure walking along the path adds a nice focal point to this orchard scene.

Gravel can be suggested using stippled pen marks or fine spatter.

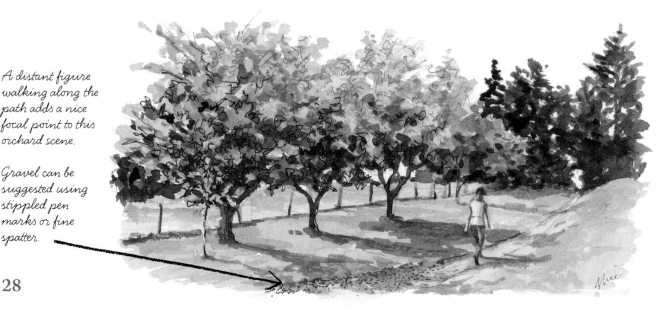

Paint a Gravel Road

It's not difficult to turn a modern highway into a nostalgic country lane. As you can see by comparing the reference photo with the painting, it's simply a matter of narrowing the width of the road and changing its color and texture from asphalt to gravel.

Reference Photo

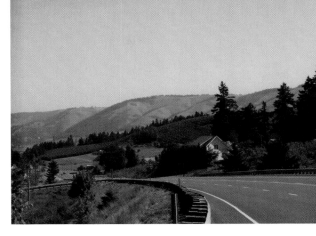

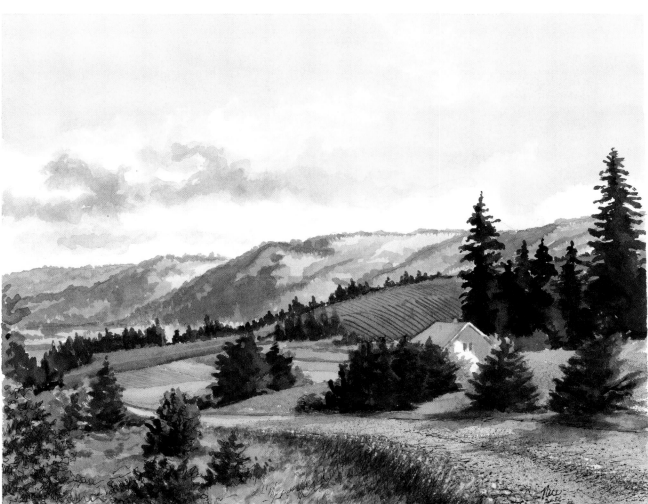

To make the gravel road appear more stable, I filled in the left bank and added a grass and pebble shoulder. The unsightly guardrail is no longer needed.

The color of the gravel is a Burnt Sienna and Ultramarine Blue mix. The pebbles were suggested using a combination of spatter, bruising and loosely penned dots and dashes. The foreground foliage was accented with scribbled pen lines.

Road to the Valley
Watercolor, pen and ink
8" × 10" (20cm × 25cm)

Livestock

If you would like to include grazing animals in your rural landscape, here are some step-by-step examples.

Step 1: Study the animal's form. Make size comparisons, head to body and so forth. Simplify the various body areas into easy-to-draw geometric shapes. Use the shapes as building blocks to rough in a light pencil drawing.

Step 2: Refine the drawing, erasing the lines of the geometric shapes as you proceed. Lay down a light wash of watercolor to establish the basic color of the animal. I used a thin flat wash of Burnt Sienna plus orange for the calf.

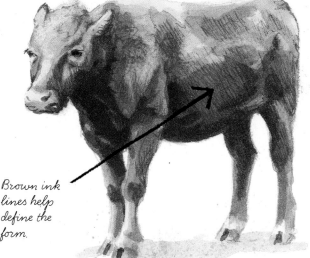

Step 3: Give the animal form by working darker color mixtures into the shaded areas of the body. Accent the painting with pen and ink, avoiding harsh outlines.

Brown ink lines help define the form.

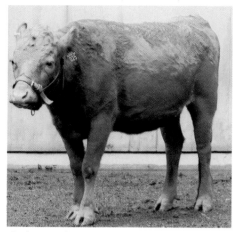

Reference Photo

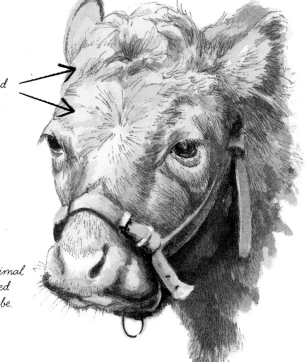

scribble and crisscross pen lines

The larger the animal is, the more detailed the pen work can be.

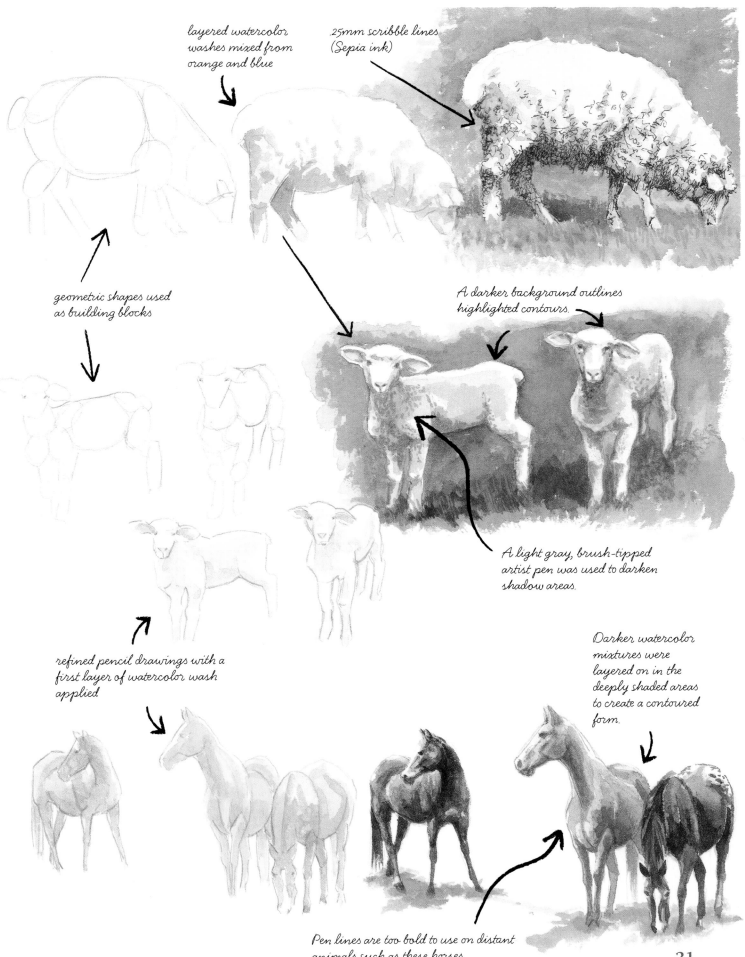

layered watercolor
washes mixed from
orange and blue

.25mm scribble lines
(Sepia ink)

geometric shapes used
as building blocks

A darker background outlines
highlighted contours.

A light gray, brush-tipped
artist pen was used to darken
shadow areas.

refined pencil drawings with a
first layer of watercolor wash
applied

Darker watercolor
mixtures were
layered on in the
deeply shaded areas
to create a contoured
form.

Pen lines are too bold to use on distant
animals such as these horses.

31

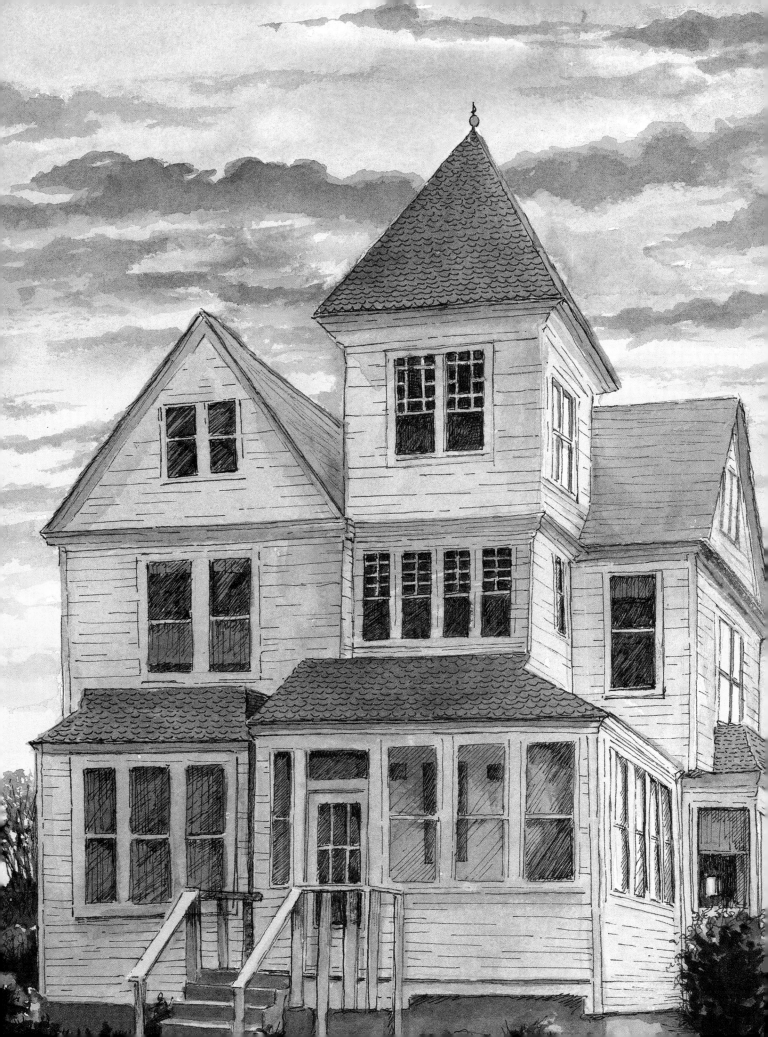

Nostalgic Buildings

The sunset hues of cream, cotton candy pink and lavender reflect off the pale clapboard walls of the aged summer home by the sea, turning her graceful three-story height into a many-facetted jewel. Some of her wavered glass windows catch and hold the splendor of the skies while others remain dark and dappled with mystery. Though summer is past and the grand old house stands empty of human company, she is alive with memories. You can almost hear the sunporch door creak open, then close with a bang, as a troupe of excited, sand-sprinkled children rush through. If you close your eyes and listen carefully, you might hear the old upright piano playing in the parlor or the chatter of the family as they gather around the dining table suitably dressed for their evening meal. Ah, nostalgia . . . those sweet memories belonging to the past! This chapter celebrates nostalgia and the homes and aged buildings that trigger those feelings. The following pages will give you a helping hand in understanding perspective and how to create a building sketch that appears structurally correct. Step-by-step instructions will show you how to age and texture your building using dry-brush techniques, glazing (thin watercolor layers), pen blending and loosely scribbled pen strokes. If you're a bit of a romantic and like to daydream about the good old days, this chapter is dedicated to you.

In this painting I mixed a little orange ink with Indigo to create a rich blue-gray tone that complemented the colors of the summer house better than either black or brown ink. The panes of glass in the windows were portrayed using diagonal lines, while the curtain folds were depicted with irregular vertical lines. The clapboard panels were merely suggested using a few broken lines that paralleled the perspective of the walls. A straightedge was only used to pencil in a few guidelines. Sketchy, hand-drawn details lend themselves well to the feeling of nostalgia.

Summer House by the Sea
Watercolor embellished with pen and ink
10" × 8" (25cm × 20cm)

Simple Perspective

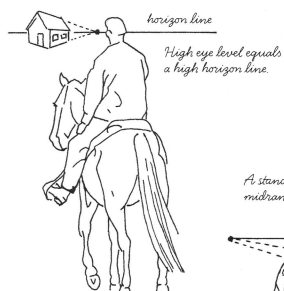

horizon line

High eye level equals a high horizon line.

The horizon is an imaginary horizontal line that marks where the earth plane meets the sky. When you are viewing a scene on location, the horizon will be positioned at your eye level, therefore the horizon line will change with your point of view. To keep your drawing in perspective there must be only one horizon line (eye level) in the composition, and all the elements placed in the scene must relate to it.

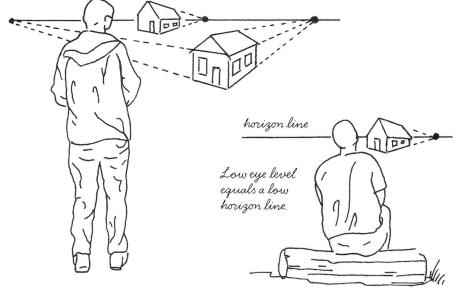

A standing view produces a midrange horizon line.

horizon line

Low eye level equals a low horizon line.

As objects recede into the distance, they diminish in height, width and clarity. All lines that are parallel to the ground plane and to each other in actual life seem to grow progressively closer together as they regress into the background, until they disappear altogether at their vanishing point (VP). There may be many vanishing points in a composition, but they must all be located somewhere along the same horizon line.

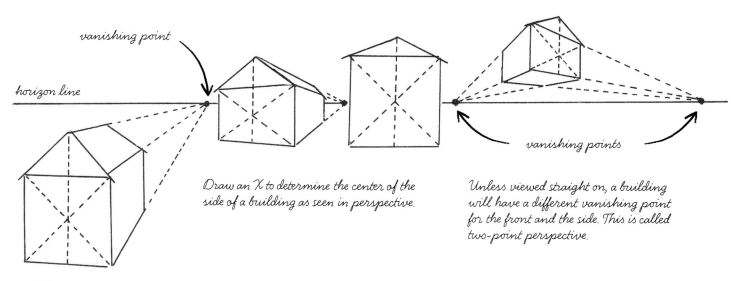

vanishing point

horizon line

vanishing points

Draw an X to determine the center of the side of a building as seen in perspective.

Unless viewed straight on, a building will have a different vanishing point for the front and the side. This is called two-point perspective.

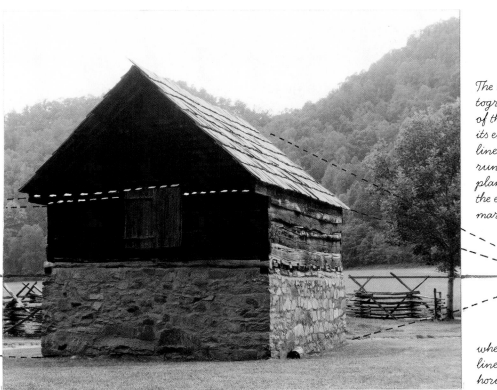

The horizon line in a photograph equals the eye level of the photographer. To find its exact location, extend the lines of the building, which run parallel to the ground plane in actuality. Where the extended lines cross marks the horizon.

horizon line

where extended lines cross the horizon

The lines on the left side of the building will also meet up at the horizon line . . . eventually.

A quick check using extended lines reveals that this pencil sketch is out of proportion. Note that the roof ridge line does not converge with the foundation and eve lines as it should.

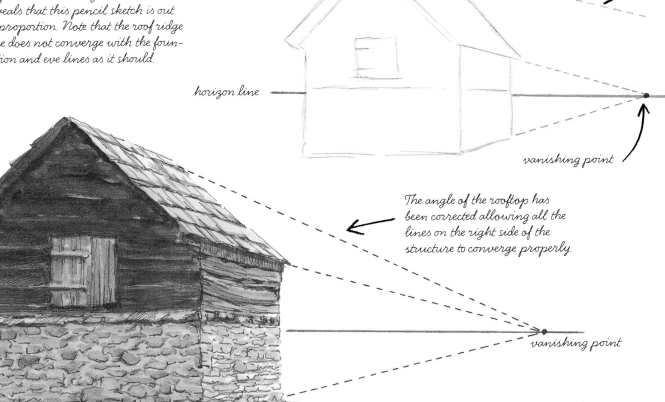

wrong angle

horizon line

vanishing point

The angle of the rooftop has been corrected allowing all the lines on the right side of the structure to converge properly.

vanishing point

35

Simple Structures

Simple structures work well as background buildings. When adding one or more of them to a landscape, make sure that they match up to the horizon line in that scene.

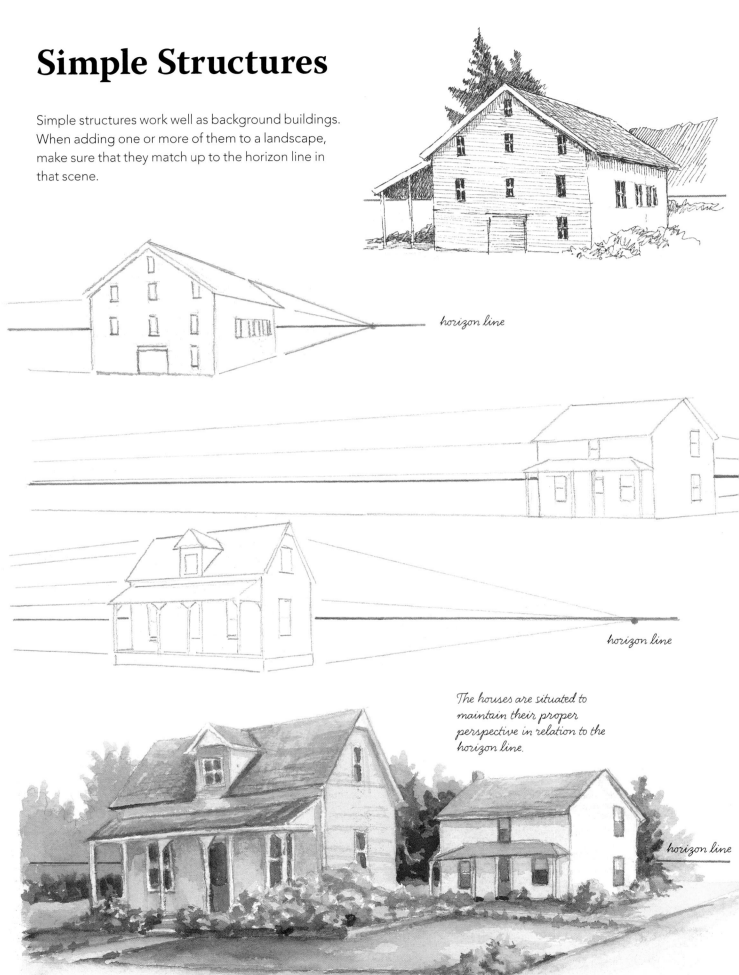

horizon line

horizon line

The houses are situated to maintain their proper perspective in relation to the horizon line.

horizon line

Quinacridone Rose + yellow-green

A second layer of daub strokes applied with a small round brush suggests a brick or stone texture.

The viewer is looking down on this English manor house from a hilltop, therefore the horizon line, indicated in red, is quite high in the scene. The extended lines running from the rooftop and eves will meet at the horizon line, off the page.

horizon line ─────────────────

Stone Cottages

Fieldstone has always been a popular building material. Its combination of texture and earthtone hues is pleasing to the eye, both in reality and as an artist's rendering. Here I used a variety of Cobalt Blue and orange mixtures to suggest the stone work.

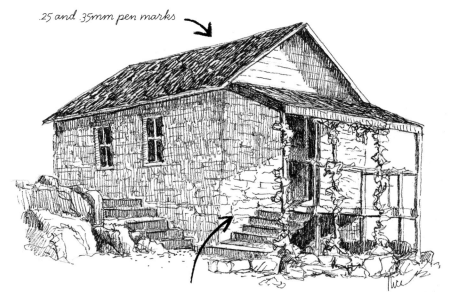

.25 and .35mm pen marks

At a distance, the texture of stone masonry can be created using broken scribble lines.

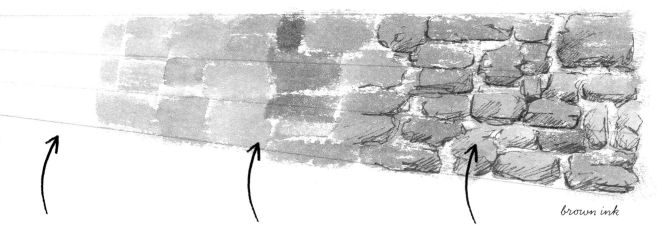

brown ink

Step 1: A few pencil guidelines will help keep your rows of stone from running askew. Remember, the rows will grow smaller and closer together as they recede into the distance.

Step 2: Use a flat brush of the appropriate size for the rocks you are creating to drybrush the stone shapes into place. Vary the size, shape and color, leaving white mortar spaces between the stones.

Step 3: Use pen-and-ink scribble lines to suggest the roughness of the rock and the shadows. Avoid completely outlining each stroke. Keep it loose.

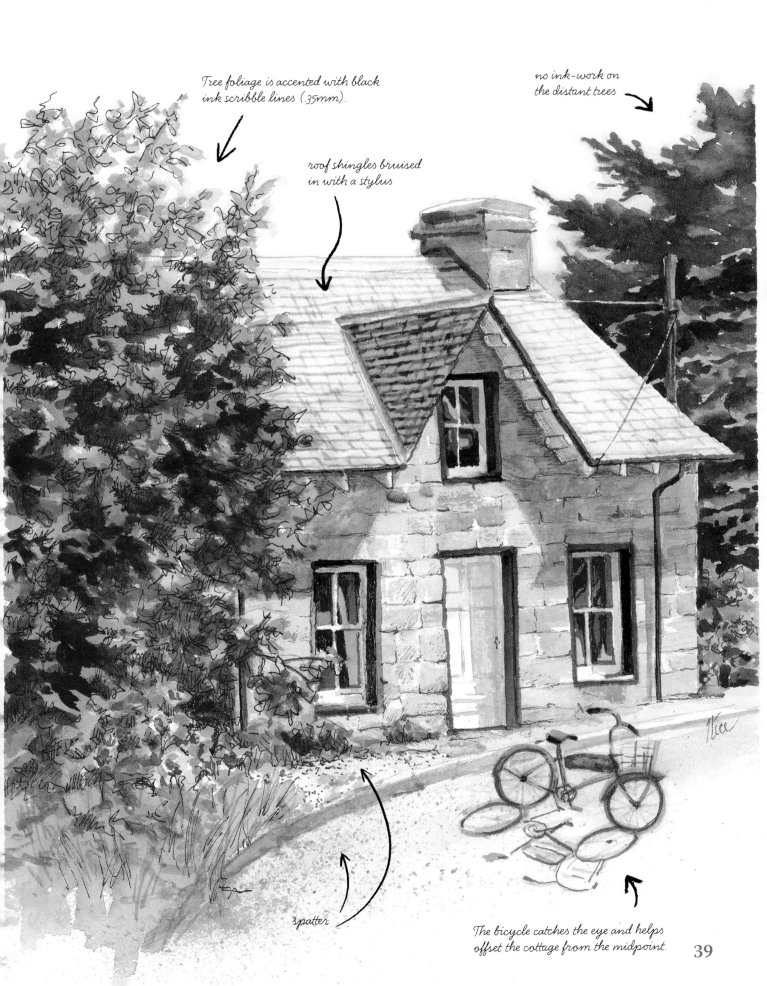

Tree foliage is accented with black ink scribble lines (.35mm).

no ink-work on the distant trees

roof shingles bruised in with a stylus

spatter

The bicycle catches the eye and helps offset the cottage from the midpoint.

39

Paint a Stone Cottage and Door

In this close-up painting of a cottage, the stonework is given more detailing using drybrush, pen and ink, and pen blending to add texture. The painting began with a simple pencil drawing of the basic geometric shapes.

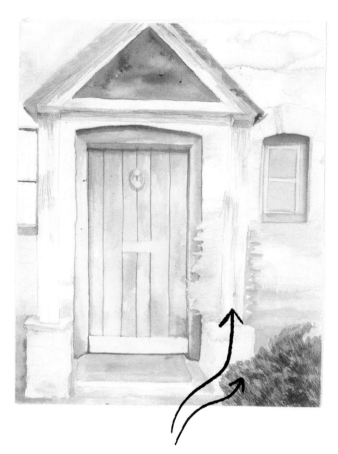

bruised texture

<u>Step 1</u>: Draw an initial sketch.

<u>Step 2</u>: Create the preliminary watercolor washes. The bush and house trim are pale blue-green muted with a touch of red-orange. Paint the stones and wooden pillars with Ultramarine Blue and orange mixes.

<u>Step 3</u>: Develop painted shadows and details. Loosely paint a darker wash mixture between the stones to represent mortar. Roughen the stones with dry-brush swipes using a ¼-inch (6mm) flat brush.

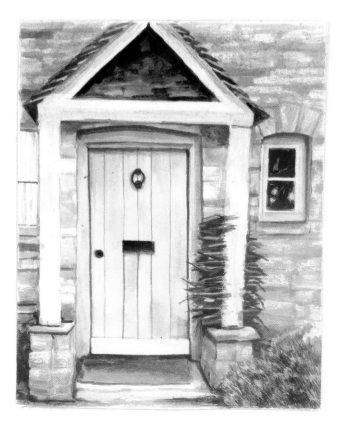

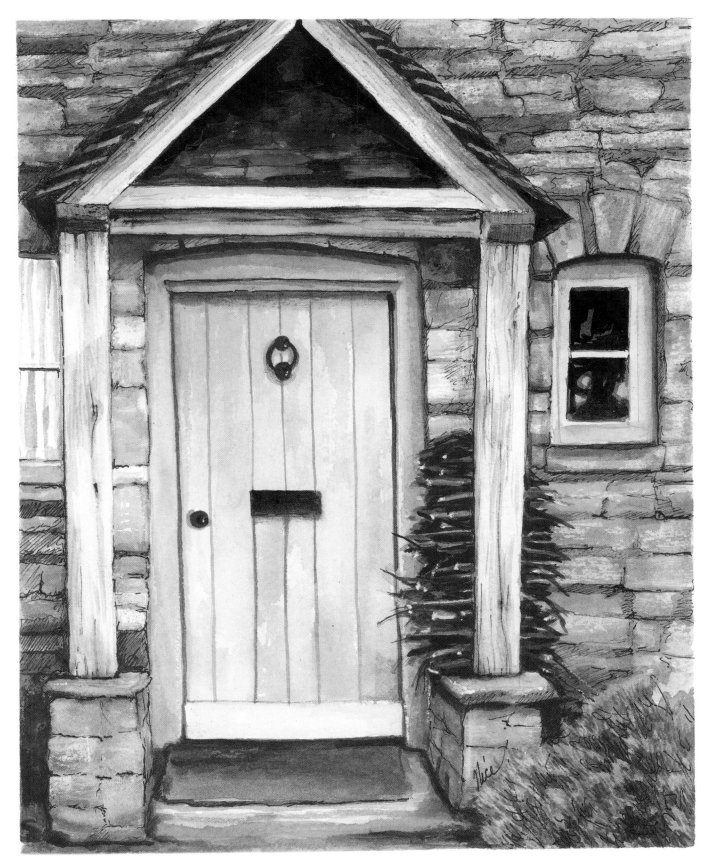

<u>Step 4</u>: Accent the painting with pen-and-ink work applied loosely. I used nib sizes .25, .30 and .35mm. Pen blending was used for a subtle look. The rough stone masonry and the stack of kindling by the door add to the nostalgic mood of this cottage.

Green Door Cottage
Watercolor and pen + ink
10" × 8" (25cm × 20cm)

Creating Character

Which of these white houses seems the most inviting? Utilizing color, style and brushwork, you can emphasize or even change the personality of a structure. By setting it against a dark and threatening sky, I created an ominous mood for the Victorian house. I deadened the lawn and made the shrubbery overgrown. A "dirty" palette, off-white color mixture accented with brown pen work lends an unkempt aspect to the dwelling. Dark windows and lowered shades suggest secrets within.

In contrast, the bright colors, the cheerful hollyhocks, and the groomed appearance of the structure and grounds lend an appealing character to the white farmhouse.

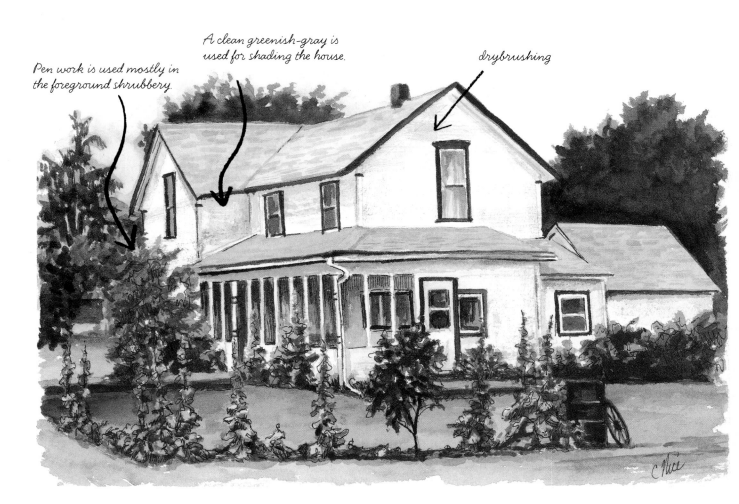

A clean greenish-gray is used for shading the house.

drybrushing

Pen work is used mostly in the foreground shrubbery.

Striving to give this ramshackle old cabin a whimsical appearance rather than a forlorn, forgotten look, I used cheerful browns and bright greens and painted in very loose strokes using a small flat brush. Scribbly pen work applied in a carefree manner enhanced the effect.

Drybrushing adds character to the wood and tin roof.

scribble-scrabble ink lines (.30mm nib)

Masking fluid was used to preserve spaces for the flower blossoms.

Paint a Victorian House

Drawing a house need not be labor-intensive, even if it's an ornate Victorian dwelling.

Step 1: Begin with a loose pencil sketch of the basic structure. It doesn't have to be perfect.

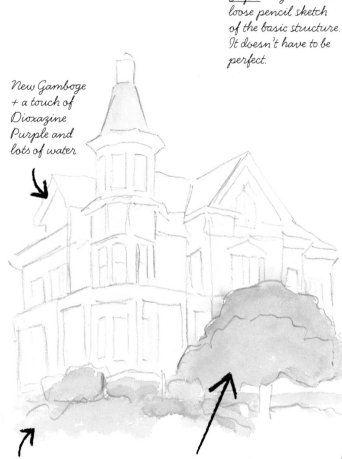

New Gamboge + a touch of Dioxazine Purple and lots of water

Burnt Sienna

Lemon Yellow + Sap Green

Step 2: Tint the house with watercolor washes, choosing the lightest color in each area.

Step 3: Add a little orange to the basic color of the house and paint the trim. Keep it loose and painterly. Darken the previous color mixtures by adding their complementary hues, and paint in the shadows. Tint the windows with varied mixtures of medial blue and Payne's Gray.

HELPFUL HINT: To quickly check the accuracy of an angle such as the pitch of a gable roof, lay a straightedge alongside the angle in the reference photo and then slide it carefully over to that same area in your drawing. If you're working in the field, sight in the angle using a straightedge, then lift your drawing up behind it to make the comparison. The trick is to keep the straightedge from shifting in the process.

Step 4: Detail the house and garden using a fine nib (.25mm) pen. It can be worked loose and sketchy or with fussy precision according to your preferred style and how much time you wish to spend on the project.

This semi-loose inking style allows for quite a bit of "gingerbread" detail.

Gazebos

The gazebo can be a tricky structure to draw due to its many sides, all of which should correspond to the horizon line. A loose, sketchy drawing can hide a multitude of small errors. This drawing was sketched on heavy drawing paper in pencil and ink, then painted in watercolor washes.

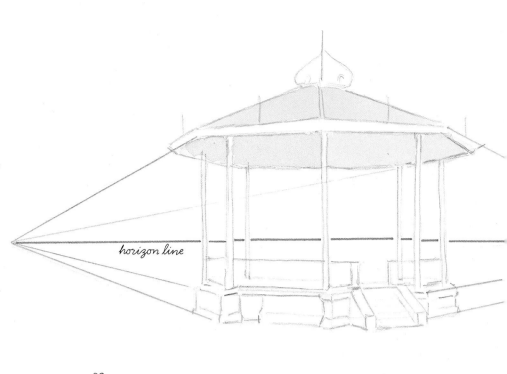

horizon line

Quinacridone Rose + midtone yellow

Cadmium Yellow + Dioxazine Purple

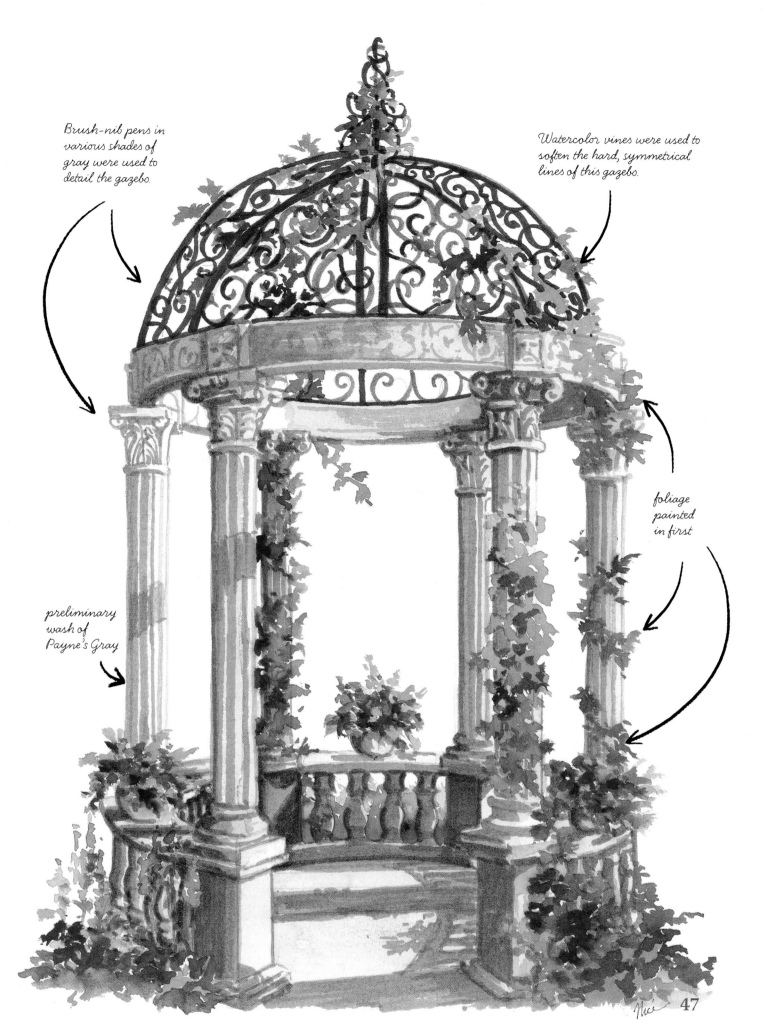

Brush-nib pens in various shades of gray were used to detail the gazebo.

Watercolor vines were used to soften the hard, symmetrical lines of this gazebo.

foliage painted in first

preliminary wash of Payne's Gray

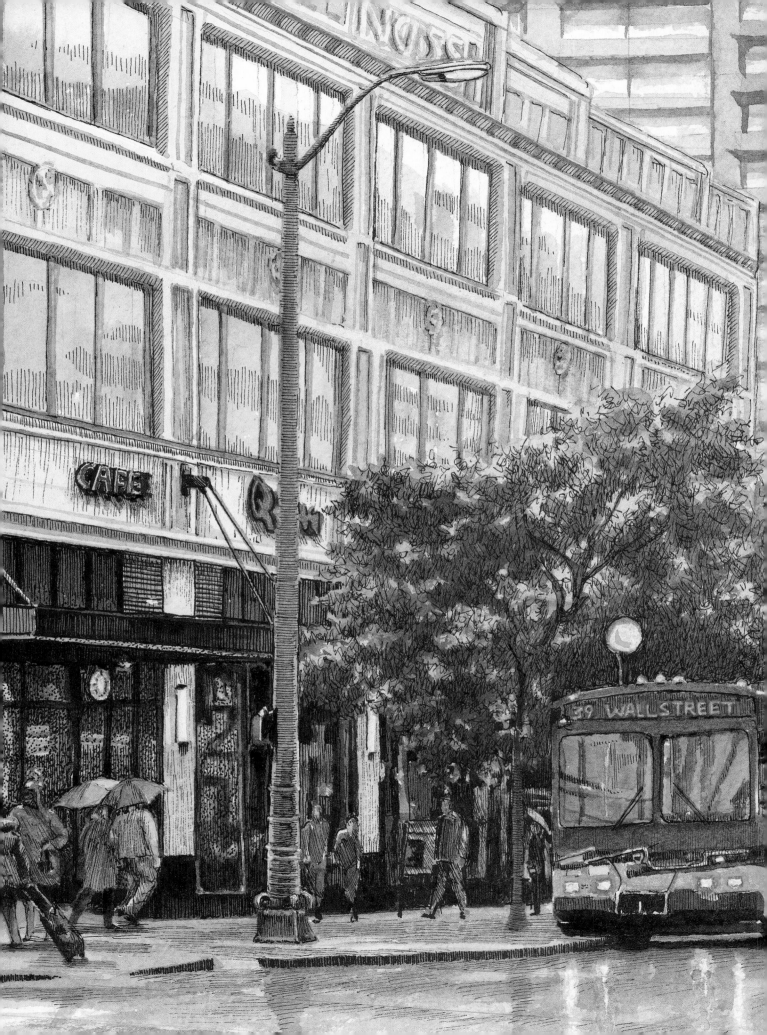

Capturing the Urban Scene

Big cities are alive with lights, color and movement. Transmitting this energy and excitement into a painting has been the worthy goal of many an art student. What may seem overwhelming at first can be conquered when studied and practiced one element at a time. This chapter includes step-by-step instructions on how to draw and paint buildings, city folk and their vehicles, neon lights, street lights and signage.

Consider the cityscape *Rainy Urban Morning*. It features all the urban elements. I first sketched it lightly in pencil using a straightedge to help align the window rows and the building perimeters. Then I worked the paintbrush and pen freehand, using the pencil marks as a guide. The painting portion of the composition was the most time-consuming, having been developed in successive layers of watercolor washes and glazes.

I chose to paint it quite detailed, but city scenes can be equally appealing when loosely rendered in an abstract or impressionistic style. Although the painting could stand alone as a watercolor, I added pen-and-ink work to develop its texture, deepen the shadows and enhance the dimensional quality. I tried to avoid harsh outlines, using value changes and broken lines to emphasize edges. Parallel and contour lines worked well to suggest smooth surfaces and windowpanes. Stippling added a bit of shadowy glimmer to the storefront windows. Scribble lines provided a fluffy depth to the tree foliage. Aside from the umbrellas and subdued lighting, one can tell that this painting portrays a rainy day by the way the bus lights reflect off the wet pavement. This effect was achieved by a strong use of white highlight and exaggerated color. Note that the bus headlights are outlined with red-orange rather than black ink, giving them a glaring quality that is repeated and magnified in the shimmering orange reflections.

Rainy Urban Morning
Watercolor enhanced with pen and ink
10" × 8" (25cm × 20cm)

49

Urban Perspective

When you sketch a scene from a some-what central vantage point looking down a straightly laid street, you will probably be using one-point perspective. All the roof edges and window rows on the building sides facing the street will have one vanishing point (A and C).

When the street is located on a hill, each building will relate to a different level situated on the rising ground and have its own vanishing point (B). This is an exception to the usual vanishing point/horizon line relationship.

A) A quick one-point-perspective sketch.

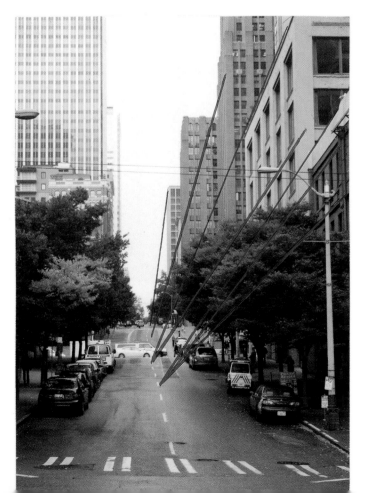

B) Reference photo of a hilly street scene with the vanishing points and perspective lines shown in red.

C) One-point-perspective reference photo.

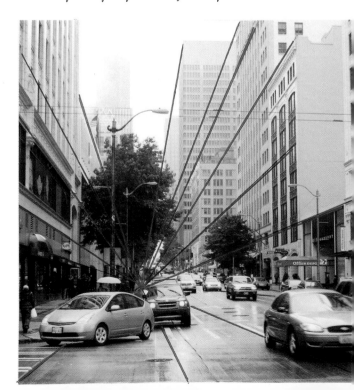

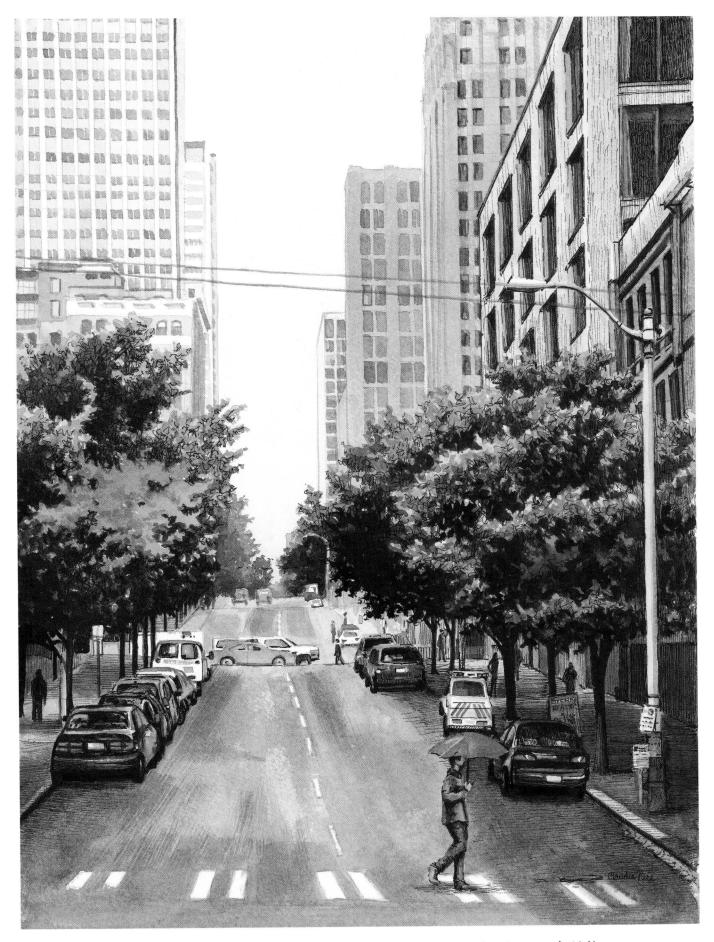

This scene was painted in layered watercolor washes, then the foreground was enhanced with black pen-and-ink lines using a .30mm Rapidograph to deepen the shadows and add texture to the tree foliage.

City Street on the Hill
Watercolor enhanced with pen and ink
15" × 11" (38cm × 28cm)

Skyscrapers

Most super tall city buildings resemble long, rectangular boxes turned on end. Drawing them so they lean slightly inward will magnify their tall, slender appearance.

Since skyscrapers must be viewed at a distance to appreciate their height, details should be kept to a minimum.

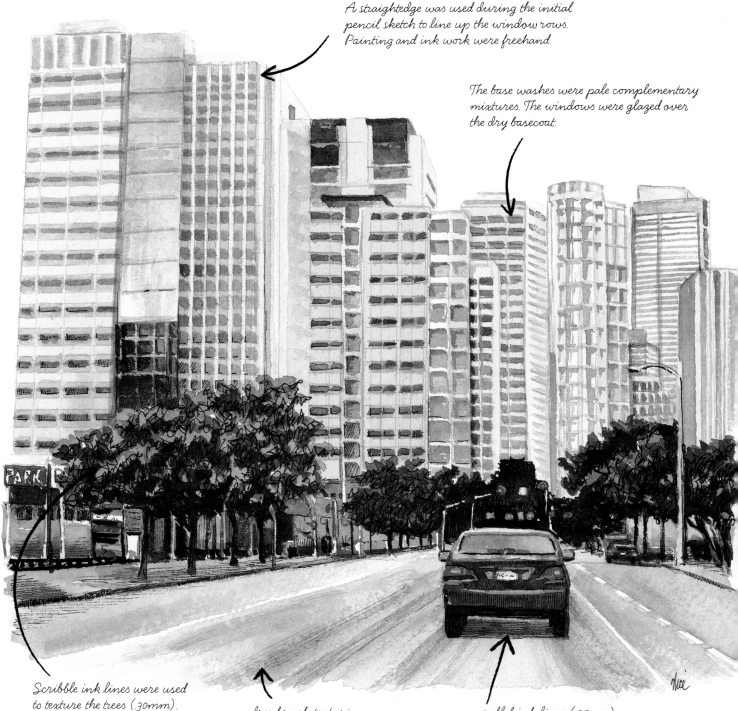

A straightedge was used during the initial pencil sketch to line up the window rows. Painting and ink work were freehand.

The base washes were pale complementary mixtures. The windows were glazed over the dry basecoat.

Scribble ink lines were used to texture the trees (.30mm).

dry-brush texturing

parallel ink lines (.25mm)

Portraying Traffic

Most modern cities contain buildings of varying age and architecture. The best way to establish a time frame for your cityscape is through pedestrian fashion and the type of vehicles shown. Cars, trucks and buses not only add color and action to the painting, they help set the scene. Here's a step-by-step example to warm up your artistic motor.

Step 1: Begin with a rough geometric pencil sketch. It probably will be boxy in appearance.

Step 2: Round out the corners of the form and add a few details. Keep it simple. Include the heavy shadows beneath the car as part of the form.

Step 3: Block in the basecoat colors. Bright color areas should be light and fairly pure in clarity (intensity). Dark areas should consist of rich grays or browns mixed from complements.

Step 4: Use layering or glazing techniques to intensify color, develop shadows and create a three-dimensional form. Make it as detailed or as relaxed as you wish.

loosely rendered

pen-and-ink embellishment

in the rain

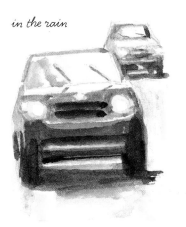

at night

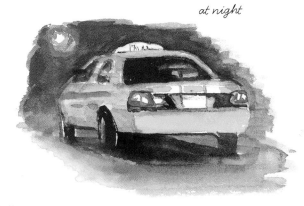

53

Populating the Scene

An urban scene looks empty without a few people strolling through it. Keep them simple and generic so they complement, not commandeer the cityscape. Here are some helpful hints for depicting figures.

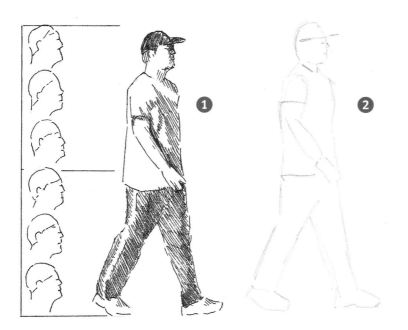

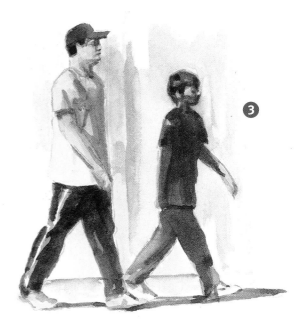

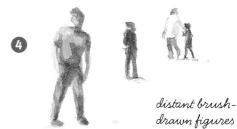

distant brush-drawn figures

❶ *The average adult figure is around six head and neck heights tall, with the midpoint at or just below the hips.*

❷ *Concentrating on general shapes, not details, draw the bulk of the body.*

❸ *Block in the various color sections of the figure, let them dry, and then glaze in the shadow areas as they appear on your model or in your reference photo. Paint shadows, not features!*

❸ *A basic skintone can be mixed from Burnt Sienna, with a touch of Quinacridone Rose added. Stir in a small amount of Sap Green to mute and deepen the hue.*

❹ *The more distant a figure is, the more nondescript it will appear.*

❸ + ❺ *Keep in mind that moving figures add energy to the scene, while standing or sitting figures provide a sense of placidity.*

Draw a jogging
figure in three
easy steps:

Step 1: Pencil
your sketch.

Step 2: Block in
the colors.

Step 3: Glaze in
the shadows.

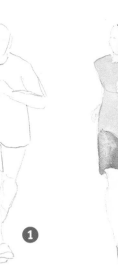

1

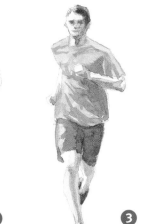

2

3

For a loose,
impressionistic
appearance, allow
the colors to bleed
into each other.

The café photo became the basis
for the painting on the follow-
ing page. Here's how it looked
in the early stages.

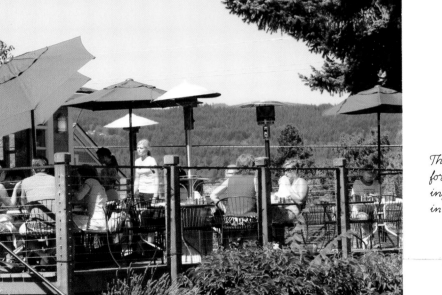

55

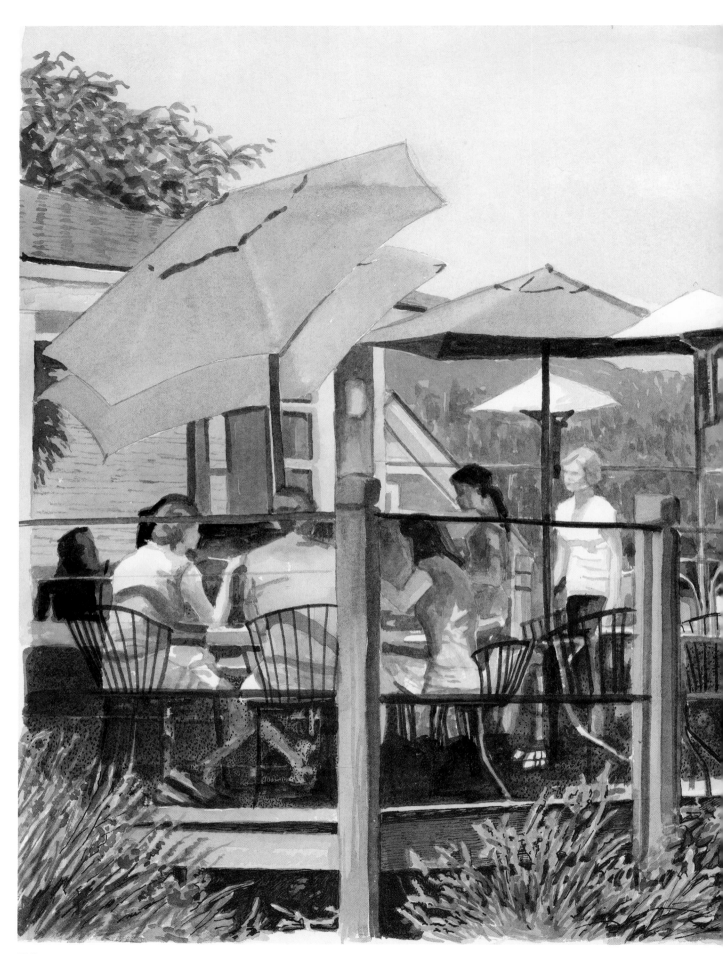

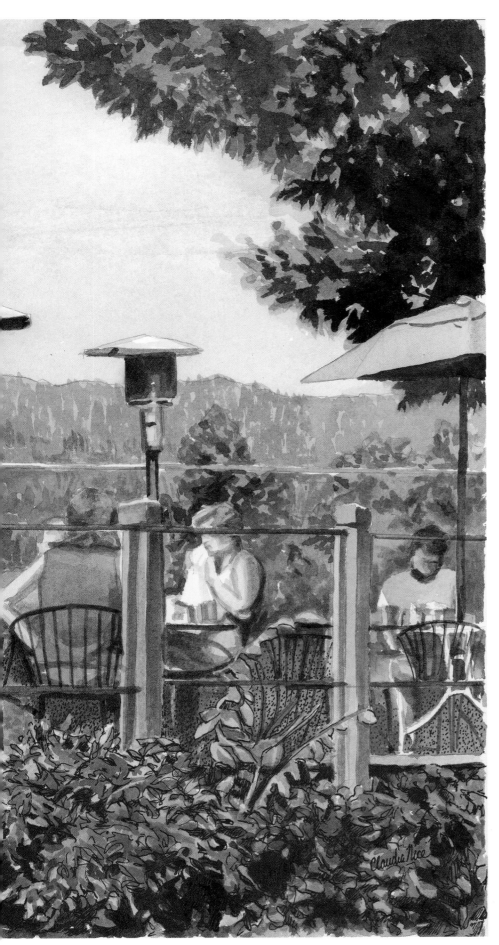

The majority of this scene is water-color, with .50mm pen stippling and scribble strokes used to deepen and break up the deep shadow areas in the foreground. Note that the facial features of the people in the painting are merely suggested using vague watercolor shading.

Dining Out
Watercolor enhanced with pen and ink
11" × 15" (28cm × 38m)

Neon Lights

The bright glow of a neon sign is a real attention getter. These lustrous luminaries work well to lure us into shops, restaurants and various entertainment establishments. They can also serve as flamboyant eye-catchers in a cityscape painting. Here are two methods of creating the neon look.

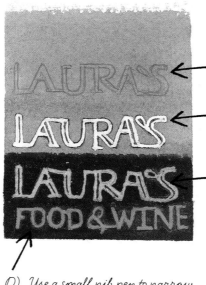

MASKED LETTERS

A) Sketch your neon letters in pencil and lay a bright flat wash over them.

B) When the wash is dry, mask the letters with a thin line of masking fluid. Let it dry.

C) Paint over the sign with Payne's Gray. Let it dry and remove the mask by rubbing it with masking tape, sticky side down.

D) Use a small nib pen to narrow and shape the neon letters as needed.

PAINTED TUBE LETTERS

Step 1: Sketch the sign and pencil in block letters.

Step 2: Create the tubular neon letter shapes within the framework previously drawn. The neon tubes should be connected. Paint them in a light, bright color.

Step 3: Add primary signage in a slightly darker tone.

Step 4: To finish, brush in a dark background and lightly outline the neon letters with a fine nib pen.

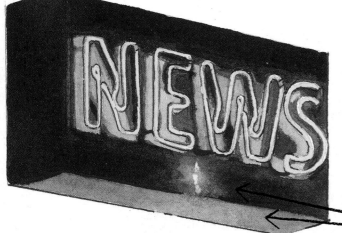

reflected lights and color

Street Signs

The writing and symbols in a street sign need not be crisp and stencil perfect to be effective. Using a fine-detail brush to create the signage will allow you to control both the color and value of the letters.

❶ *razor-scraped lettering*

❷ *Distant signs should be vague.*

❸ *Drybrushing produces soft, broken-edged lines.*

❹ *no. 3 round detail brush*

❺ *A red basecoat was laid under the Payne's Gray layer. Using a damp brush, the dark paint was lifted to produce a glowing effect.*

❻ *red color painted around "paper white" letter*

❼ *graffiti*

❽ *pen-and-ink detailing in the foreground*

59

Painting Night Lights

The city after sunset assumes the color of the artificial lights illuminating it. In the painting shown here, the bright lamp globes are encircled with orange halos. This orange glow influences the overall color scheme.

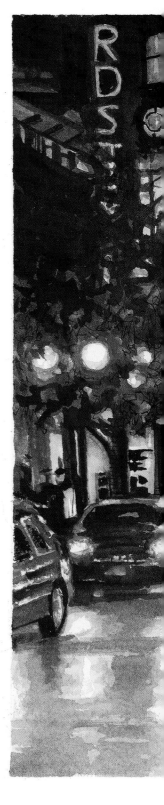

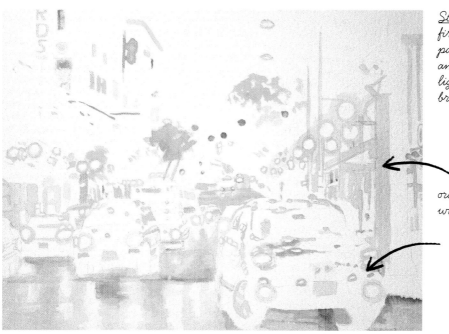

Step 1: In the first steps of the painting, locate and block in the light and the bright areas.

orange muted with blue

Include reflected spots of color.

Step 2: Using layering and glazing techniques, begin to add depth and form.

orange muted with Burnt Sienna, Burnt Umber or Sepia

Headlights should glare white and bright. Halos of various tints surround them.

Maintain the white of the paper.

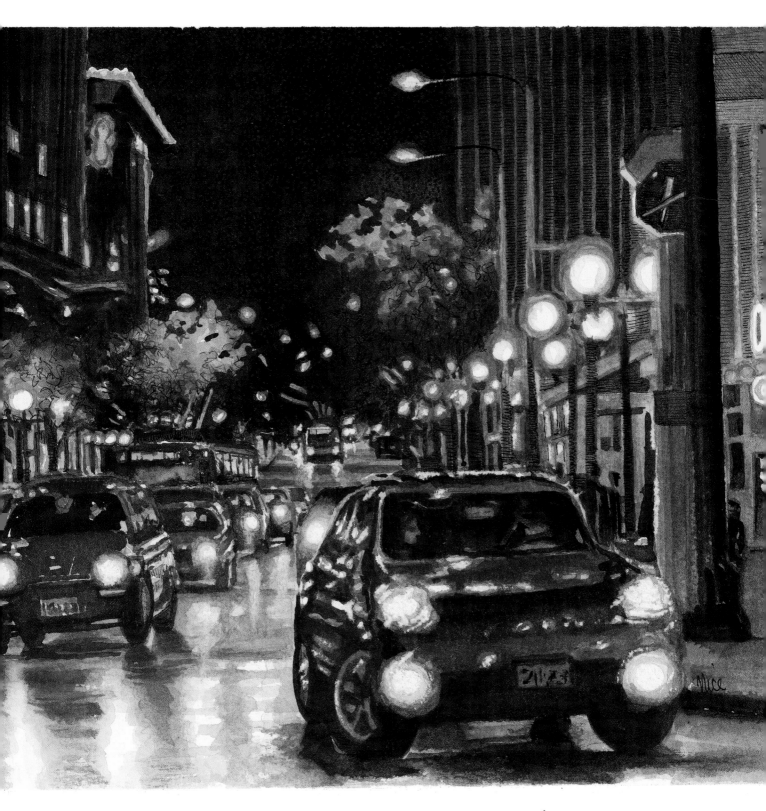

Step 3: For the finished painting, I used stippling, scribble lines and parallel lines to texture the background and left the lively foreground uninked.

A well-lit night scene is strong in value contrast. It should range from near black to paper white, with lots of light play in between. Patches of reflected color may form a hard-edged glint or softly fade at the edges. Use damp brush blending, blotting or razor-scraping to soften the edges.

Night Lights
Watercolor enhanced with pen and ink
8" × 10" (20cm × 25m)

First Impressions

The miniature paintings on this and the following page began as loose impressionistic sketches painted directly in washes of watercolor without preliminary pencil work. The result is fresh and spontaneous but somewhat vague.

A spontaneous pen-and-ink sketch of a street musician (.25mm).

Overlaying the painting with a relaxed pen-and-ink drawing adds focus and depth without spoiling the overall effect.

sketchy, whimsical pen work

objects and figures not overly defined (.25 and .30mm pen nib)

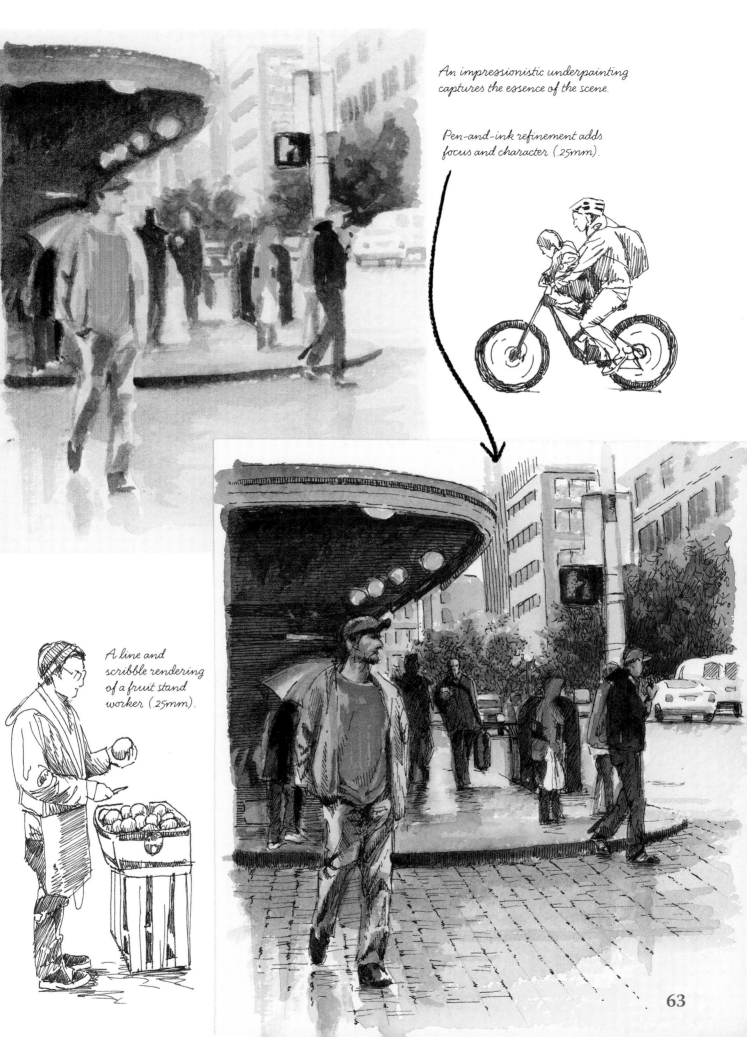

An impressionistic underpainting captures the essence of the scene.

Pen-and-ink refinement adds focus and character (.25mm).

A line and scribble rendering of a fruit stand worker (.25mm).

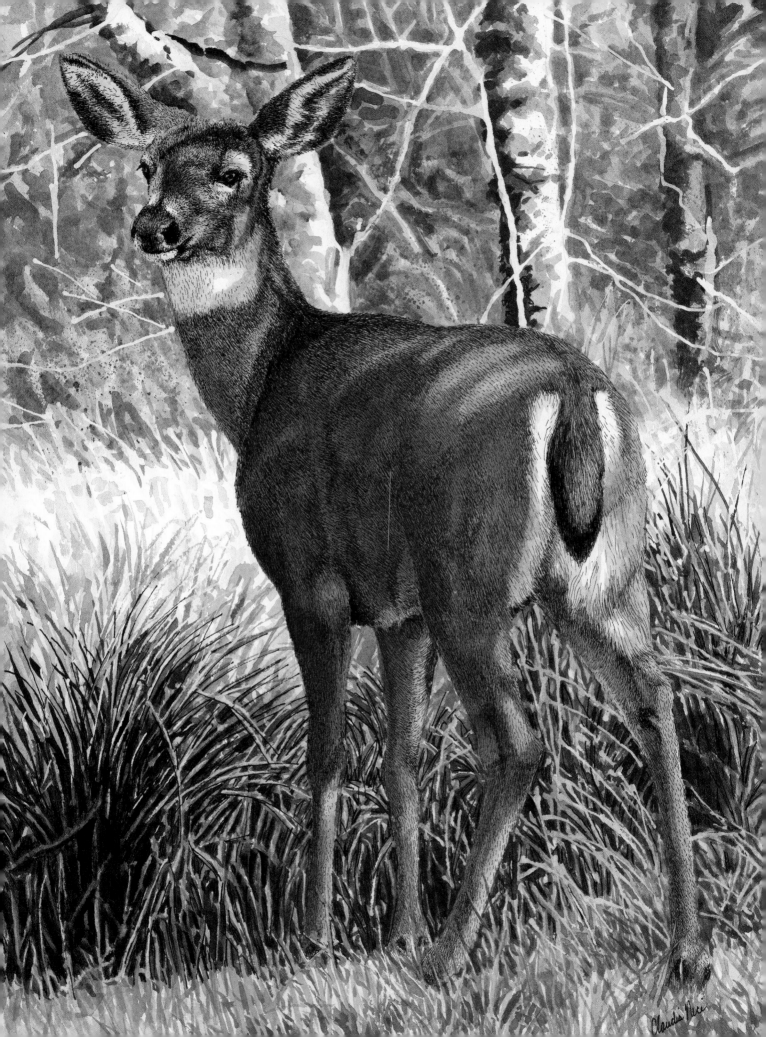

Wild Wanderings

I think that the best way to enjoy nature involves more than simply stepping out of doors or sitting in the sun. I think that total enjoyment involves all of the senses. Taking time to smell the roses is good advice. This chapter is about slowing down and appreciating nature to its fullest, from the birds and other animals to the simple leaves and berries. Take a little time to ponder the wild side of your environment. Hike a trail, stroll a country lane, visit a community park or simply walk around the block. As your mind relaxes, stop and close your eyes. Do you hear birdsong or the rustle of leaves? What do you smell? Is it the earthy scent of the forest, the fragrance of blossoms or perhaps the musky odor of fallen autumn leaves? Open your eyes and touch. Run your fingers over the bark of a tree, feel a flower petal against your cheek or let a caterpillar crawl across your hand.

I've been known to nibble wild leaves, roots and berries, but be knowledgeable about wild plants before you engage your sense of taste. Now that you're beginning to experience nature, let your eyes observe in depth. Contemplate the shapes, shadows, colors and textures. Make a sketch and by all means take photographs. Nature doesn't stand still for long. Even if your chosen subject is planted in the ground, the sun moves and with it those lovely cast and contour shadows. Take a deep breath of fresh air . . . it's time to paint!

Consider the deer painting in *Black-Tailed Deer*. It's the main subject, upfront and large enough to see the individual hairs on the coat. Short crisscross ink lines detail the coat and suggest its texture. Observation, along with backup photos, helped me know in what direction to lay down the pen strokes and which areas to work heavier to create contours and shadows. Note the grassy marsh and the forest behind the deer. Backgrounds are as important as the subject, even if they are only snatches of shape and color. A well thought-out setting can describe the animal's habitat, hiding places and perhaps what it eats. Wander through the rest of the chapter to discover other representatives of the wild world.

Black-Tailed Deer
Watercolor embellished with pen and ink
15" × 11" (38cm × 28cm)

Wild Animal Portraits

When an animal dominates the scene and is portrayed large enough that individual hairs are noticeable, then crisscross ink strokes work well for textural enhancement. Each crisscross line should be no longer than the hair it represents.

Close-up animals are an exception to my usual paint-followed-by-ink procedure. I find that if the ink strokes are applied first, the coat will have a smoother, more unified appearance. This was sketched with .30mm and .35mm Rapidograph pens.

The arrows indicate the hair direction of the coat.

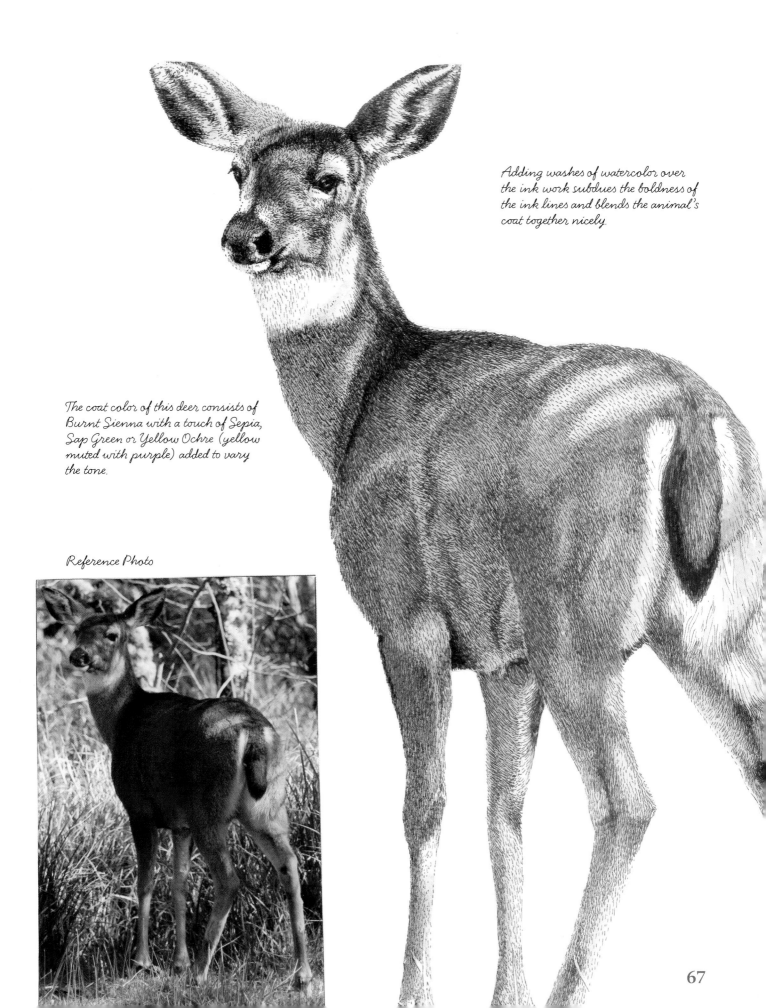

Adding washes of watercolor over
the ink work subdues the boldness of
the ink lines and blends the animal's
coat together nicely.

The coat color of this deer consists of
Burnt Sienna with a touch of Sepia,
Sap Green or Yellow Ochre (yellow
muted with purple) added to vary
the tone.

Reference Photo

67

Funny Fat Frogs

The round, fleshy contours of a frog have lots of softly blended contour shadows and a few sharp-edged white highlights.

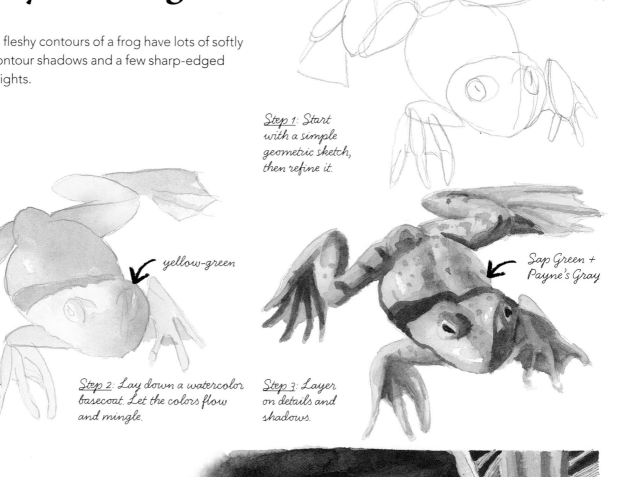

Step 1: Start with a simple geometric sketch, then refine it.

yellow-green

yellow + purple

Step 2: Lay down a watercolor basecoat. Let the colors flow and mingle.

Sap Green + Payne's Gray

Step 3: Layer on details and shadows.

Step 4: Add pen-blended brown ink spots (.25mm).

The Dramatic Dragonfly

These bold little bog residents have two sets of
transparent wings, which they can move indepen-
dently, allowing them to fly forward or backward with
astonishing speed. When depicting a dragonfly larger
than life size, make dots and dashes with a .25mm pen
to suggest the tiny wing veins. Overlaying the white
patches with a thin layer of white acrylic will allow the
veins to show through in a subtle manner.

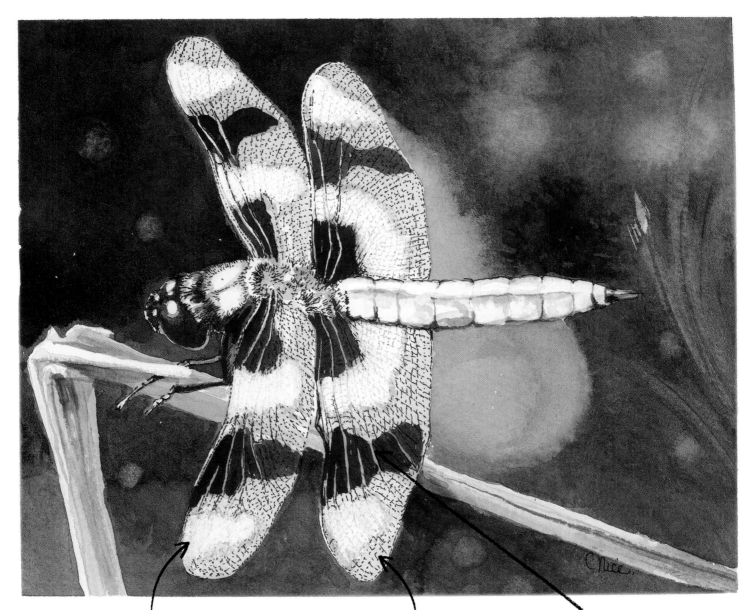

thin layer of white acrylic paint

*Pen-and-ink stippling adds the
texture of veins to the wings.*

*In the dark spot areas, the large
veins are left unpainted and later
tinted a light brown.*

Colorful Koi

Although these flamboyant fish aren't wild in the same sense as trout or bass, their flowing lines and bold primary hues make them a popular wildlife subject.

Some koi are smooth and scaleless, while others have leathery dorsal plates or large, shiny mirror scales. Most common is a uniform net-like pattern of small scales that run from the back of the head down both sides of the body.

Step 1: Form two rows of diagonal lines.

Drawing a scale grid will help you place the scales in an orderly formation.

Step 2: Crosshatch the first sets of lines to create a uniform diamond pattern.

normal scales

Pen-and-ink work can be used to enhance the eyes, dark scale edges and spots.

Step 3: Round the diamonds into crescent shapes.

scaleless leatherback

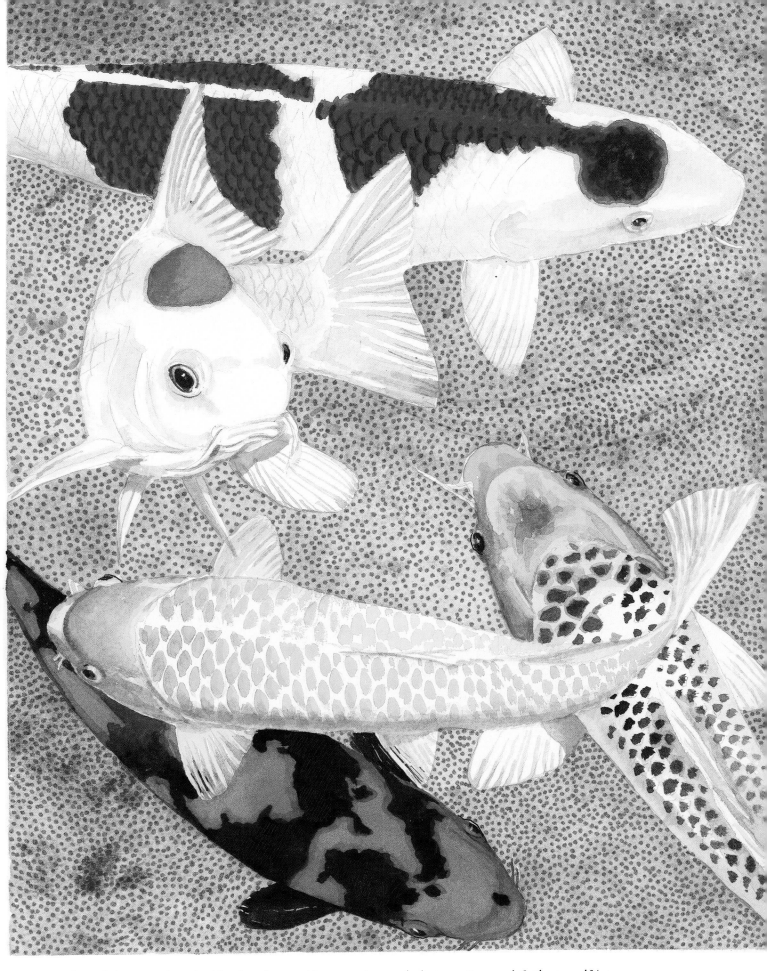

Stippled pen work with a blue brush pen adds nice texture to the koi painting. *A Gathering of Koi*
Watercolor enhanced with pen and ink
11" × 8½" (28cm × 22cm)

Depicting Fluff and Feathers

I rely on two basic shapes when drawing the form of a bird; an egg shape for the body and an oval or circle for the head. The bill, neck, legs and feet will vary according to the species and its feeding habits.

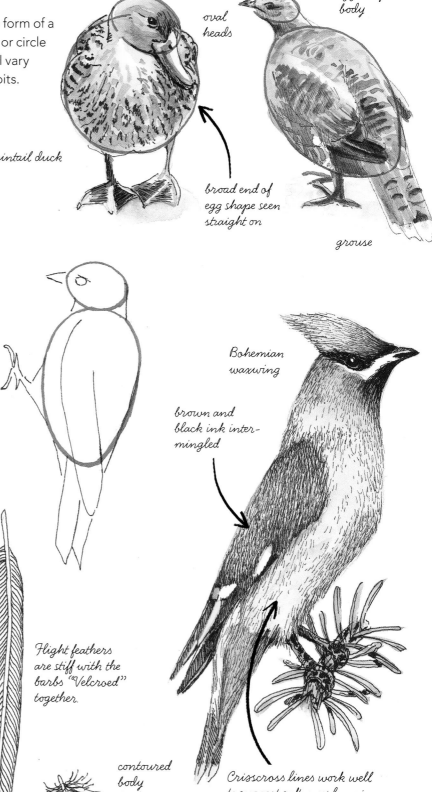

oval heads

egg-shaped body

pintail duck

broad end of egg shape seen straight on

grouse

Bohemian waxwing

brown and black ink intermingled

downy woodpecker

Flight feathers are stiff with the barbs "Velcroed" together.

wavy barb lines

contoured body feather

Crisscross lines work well to suggest soft, overlapping body feathers.

down

Nest Building

Barn swallows sculpt their nests out of mud daubs, straw and string. Here's a simple way to duplicate the texture.

brown crisscross ink lines

Masking was used to create straw and string lines.

Step 1: Lay down a base wash of pale browns and grays. Let dry.

Step 2: Brush Sepia watercolor across a synthetic sponge and press it gently over the base wash.

Creating Mottled Feathers

The body feathers on numerous birds appear speckled. This look can be achieved easily by using one of the techniques shown below or combining several of them. Be creative and see what you can do.

Orange + Blue Equals . . .

. . . a variety of browns and grays that work well as the basecoat for mottled feather techniques. For the best results, don't overblend the color mixtures.

<u>*Moist Surface Spatter*</u>

While the basecoat is still damp, use your finger to flick the bristles of a flat brush loaded with darker paint. The spatter will spread paint above the wash according to the moistness of the surface.

<u>*Pen Blending*</u>

Allow the basecoat to dry, then re-dampen it with a moist brush. Stroke it with a .25 or .30mm pen nib in dots or short dashes. Brown ink was used in this example.

<u>*Sand and Spatter*</u>

Lightly sprinkle sand into a wet basecoat and spatter water drops over the mix. Light patches will form. Brush away the sand when the wash is dry.

<u>*Salt*</u>

Prepare the table salt by spreading it on a paper towel and heating it in a microwave, one minute on high. Sprinkle it sparingly into the wet basecoat and wait for light patches to form. Results will vary. Remove the salt when the wash is dry.

The watercolor owl was textured using the sand and spatter technique and then accented with both black and brown crisscross pen-and-ink lines. →

Camouflaged Owl
Watercolor enhanced with pen and ink
11" × 8½" (28cm × 22cm)

Wild Winter Berries

During a chilly December walk in the woods, I came across these berries shining like plump jewels. Although inedible, snowberries and holly berries are fun to gather and carry home for a warm and cozy painting session.

As I studied the snowberries in my studio, I found them to be more the color of old ivory than white, with a waxy sheen. A dark background sets them off nicely.

pencil, pen-and-ink quick studies

holly berries (Aquifoliaceae)

snowberries (Symphoricarpus)

brown pen and ink

wild rose hip (edible but not palatable)

yellow + purple applied in glazes

ivory snowberries with a waxy sheen

top side shiny

underside dull

Step 1: Draw a preliminary pencil sketch.

Step 2: Apply a thin wash of red watercolor, excluding highlight dots.

Step 3: A second red wash is added to richen the color.

Step 4: Shadows are blended into place.

red + green mixture

brown ink

76

brown scribble lines

These paintings of wild rose hips represent two different techniques involving pen, ink and watercolor.

This example is quick, loose and impressionistic. It was drawn directly in watercolor, allowing the color to mix and mingle spontaneously. Fine scribble lines were used to help define the forms and add a hint of texture.

This example is a detailed, realistic painting that was developed in glazed washes. Color changes on rounded surfaces were carefully blended along the edge using a clean, damp brush while the most recent glaze was still moist.

Both dry and pen-blended ink work was used to add interesting details and texture.

blended glazes

brown ink

Create Ink Prints with Leaves

Ink prints are a fun procedure that begin with the collection of leaves. They will need to be clean, dry and able to lie flat against the painting surface.

<u>Step 1</u>: Lay the selected leaf underside-up and brush it with a thin coat of acrylic paint or acrylic-based ink. (Watercolor doesn't adhere as well to the leaves and smears when tinted with additional color.) Blot off excess paint and you're ready to print.

watercolor-enhanced leaf print

Blue-gray shadow gives the leaf depth.

incomplete print filled in with brush and ink

brown ink maple leaf print

<u>Step 2</u>: Place the painted side of the leaf against the work surface, cover it with a paper towel and rub the contours of the leaf vigorously with your finger. Prints that are incomplete can be enhanced with a brush or pen. Add watercolor washes and pen work to make it glow with virtual reality.

black ink touched to a moist surface (pen blending)

The fungus spot was created with Payne's Gray + Dioxazine Purple + black pen stippling.

Leaf prints enhanced with pen, ink and watercolor.

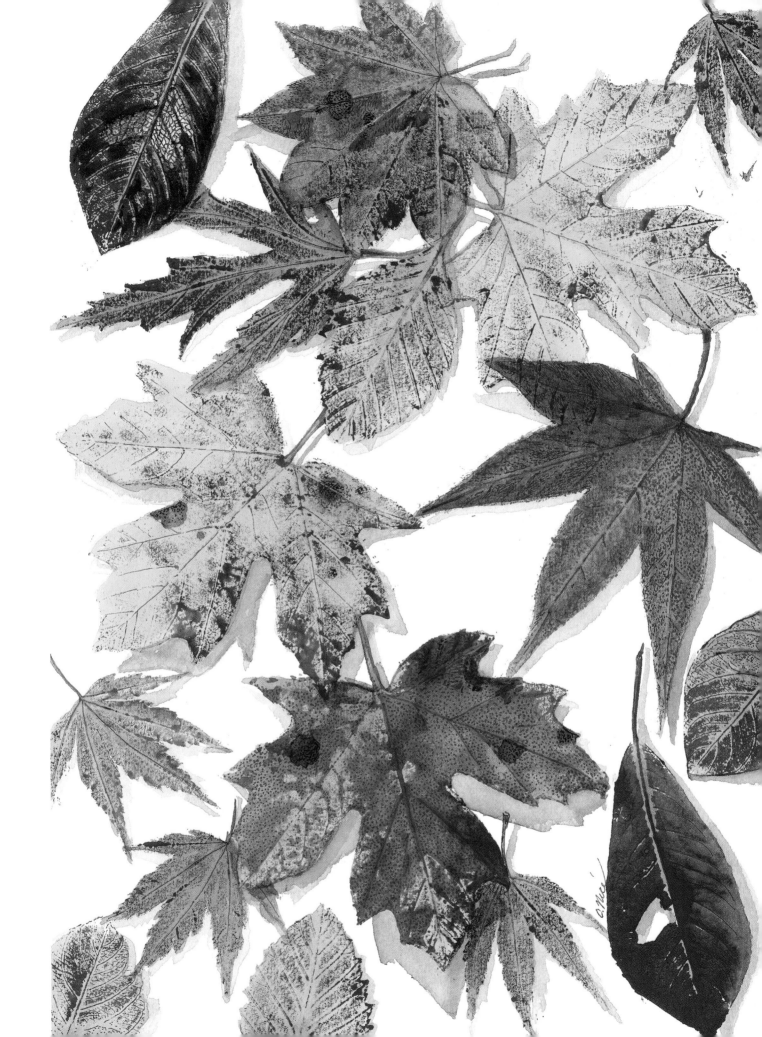

An Alpine Meadow

I live in the foothills of Mt. Hood, Oregon. The mountain vistas continue to inspire me as I seek new ways to portray my natural surroundings. In this mountain meadow landscape, I used actual fir twigs to create ink prints in the foreground branches. Some of the needles on the back side had to be removed to make it lie flat for the printing process.

I used dark green acrylic paint to create the fir prints in the painting's foreground.

In the finished painting, watercolor was brushed on to fill in missing paint areas, and then a loose outline was applied to help define the branch and pop it forward. I used pen and ink to enhance the texture of the background trees.

Alpine Meadow, Mt. Hood
Watercolor, acrylic ink prints, and pen and ink
11" × 15" (28cm × 38cm)

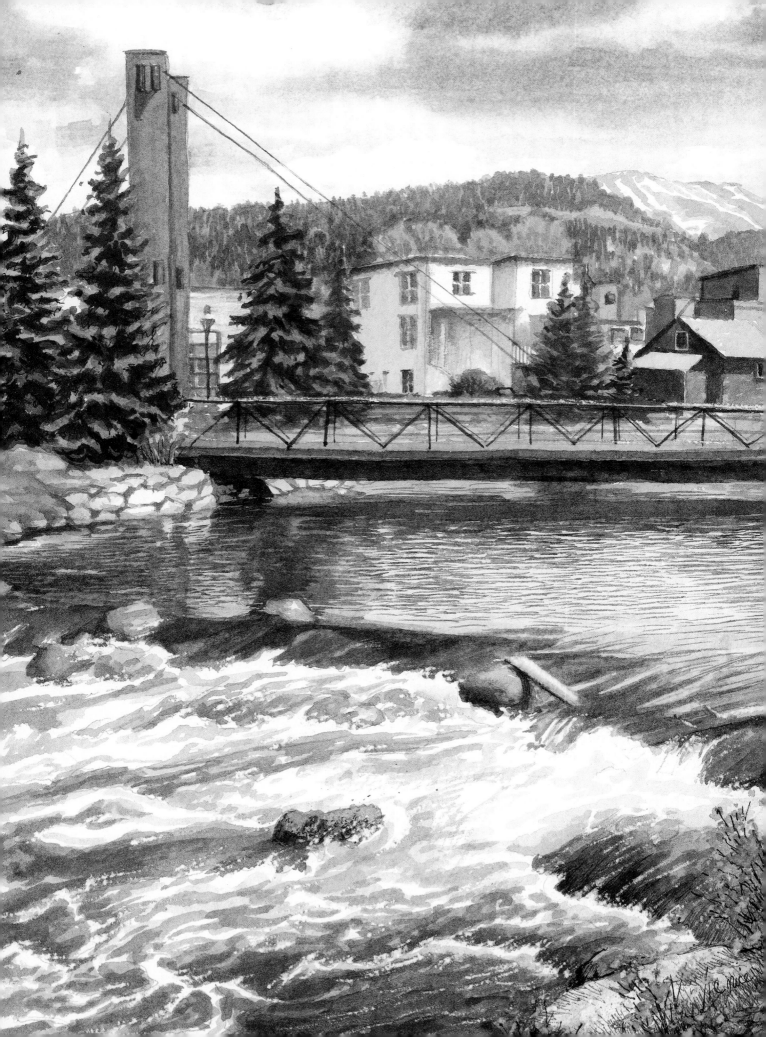

Waterways

One of the questions asked most often when my art students are working on aquatic landscape scenes is "What color should I paint the water?" Bodies of water permeated with a foreign substance do have local color . . . algae green, muddy brown or the milky tint of glacier melt. However, water in its purest state is transparent. It has no color of its own. If we can't paint the water, then we must resort to painting the objects beneath it, within it and floating on top of it; and most importantly we must portray the reflective shapes and colors glinting off its surface.

In *Flowing Through Breckenridge*, the stream meandering through the mountain village is swift, its calm surface marked with sedate, horizontally placed ripples. It reflects the blue of the sky intermingled with reflections from the shore. As the stream sweeps down to a lower level in the foreground, we see rocks and driftwood beneath its transparent flow. We know that these objects are underwater because their shapes are less distinguishable and their color is deeper and more vivid than their dry counterparts. At the bottom of the drop, the stream encounters a bed of protruding boulders. The relentless current slams into the obstacles, whipping itself into frothy foam and whitewater spray. The patches of moving water peeking through the white turbulence reveal the color of the rocks beneath in a muted hue, and the water is no longer transparent, having been infiltrated with a myriad of bubbles.

In this one aquatic landscape, the water has revealed many of her personalities, each of which requires a different technique or color to portray. Observation is the key. Spend some time near the water and see it with an analytical eye. Experiment. If you can capture its mood or movement, you're making great progress. Paintings need not be photo-perfect to be successful, but if you long to portray the various waterways the way nature presents them, then the pages of this chapter were designed to lend you a paddle and float you on your way.

Flowing Through Breckenridge
Watercolor, razor-scraping, and pen and ink in the trees and foreground
10" × 8" (25cm × 20cm)

Still Water

As illustrated by these miniature marsh paintings, still water is like a mirror reflecting whatever is above it. In open areas it will most likely take on the blue of the sky or the color of the clouds. Flat watercolor washes work well to portray the reflective surface.

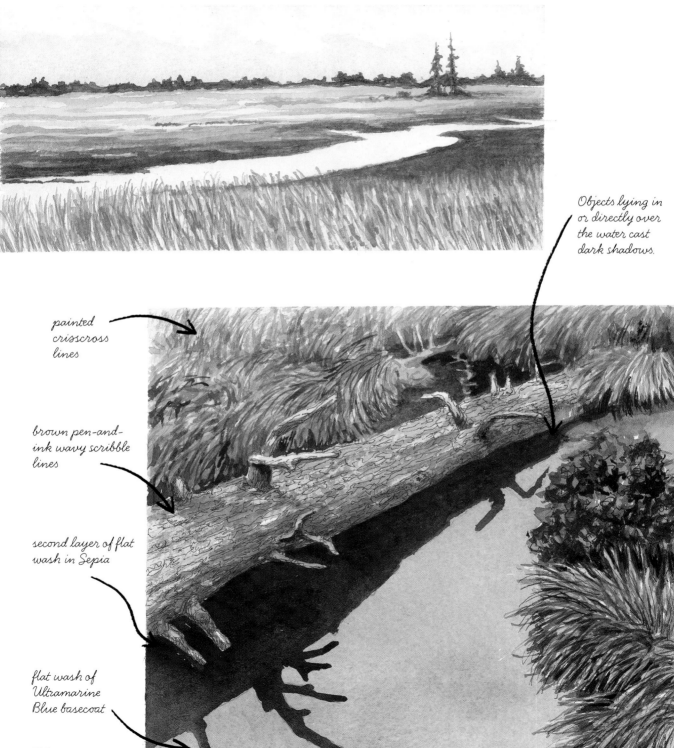

Objects lying in or directly over the water cast dark shadows.

painted crisscross lines

brown pen-and-ink wavy scribble lines

second layer of flat wash in Sepia

flat wash of Ultramarine Blue basecoat

Reflected images are wonderful for adding color, value contrasts and interesting patterns to still water surfaces. In the painting seen here, the reflected forest seems to stretch into the depths of the lily pond. To create this illusion, I used two coats of a Sepia/Sap Green mix applied in vertical brushstrokes, followed with black, parallel pen lines.

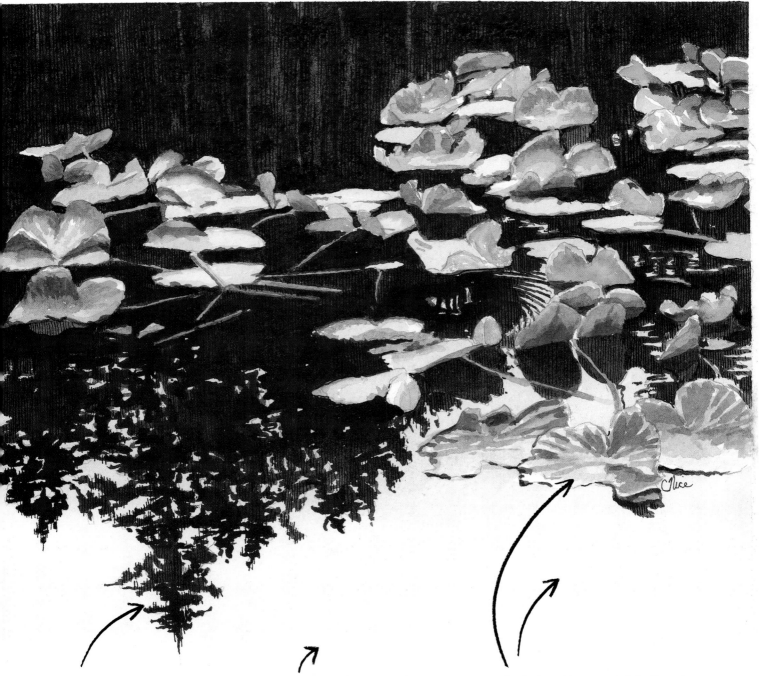

Vertical ink lines add depth to the reflection.

flat wash of a very pale Ultramarine Blue

Both the still water and the flat, shiny lily pads reflect the light of the sky.

Reflections and Distortions

If you laid a large mirror on the floor and had a friend stand on the far side with her palm extended over the mirror, not only would you see an upside-down image of your model, but you would see the underside of her hand. Since ground-level puddles, ponds and lakes reflect a different perspective than one sees at eye level, it's best to draw reflections from observation rather than any set formula.

When still water is disturbed, even slightly, reflected images become distorted. The slight movement of a floating dock as people walk across it is enough to cause their reflections to ripple.

If reflections are cast across gentle swells, an undulating striped pattern forms. The reflected image stretches sideways as it rides the peaks and valleys of the swells.

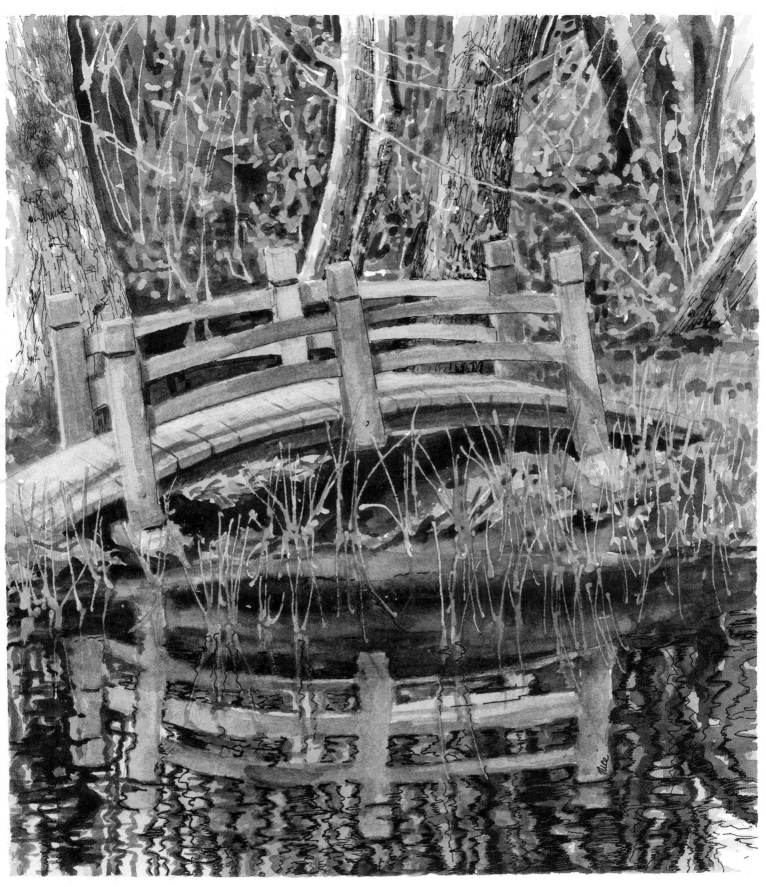

In the pond painting seen here, the bridge reflection and the rippled color bands in the foreground designate it as a water area. Masking fluid was used to protect the reeds and underbrush during the initial painting steps. Scribbly ink lines add texture.

Rustic Moon Bridge
Watercolor, pen and ink
10" × 8" (25cm × 20cm)

Wind Riffles

When the wind strikes a still body of water, it pushes the surface into small wavelets or riffles. This disturbance may appear in patches or cover the entire surface.

To suggest wind riffles on an open body of water, lay down a flat wash the color of the sky. Let it dry and then use a rigger or small round detail brush to cover it with tiny horizontal dashes in a slightly darker hue.

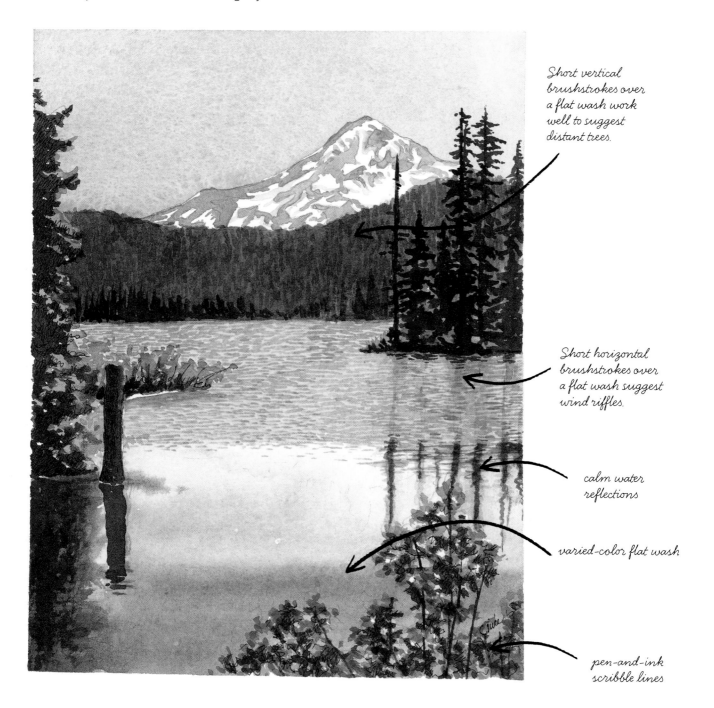

Short vertical brushstrokes over a flat wash work well to suggest distant trees.

Short horizontal brushstrokes over a flat wash suggest wind riffles.

calm water reflections

varied-color flat wash

pen-and-ink scribble lines

The Babbling Brook

Clear, shallow water flowing calmly over a rocky creek bed will have a gentle rise and fall as it moves along. Bits of overhead reflection will show up as light ribbons of color that follow the direction of the current. Rocks lying below the water will appear darker and more colorful than the dry ones above the flow.

ribbon of reflection

To depict a babbling brook in watercolor, paint the reflective ribbons first and then fill in the rocks behind them.

Dry rocks show greater detail and texture than wet ones.

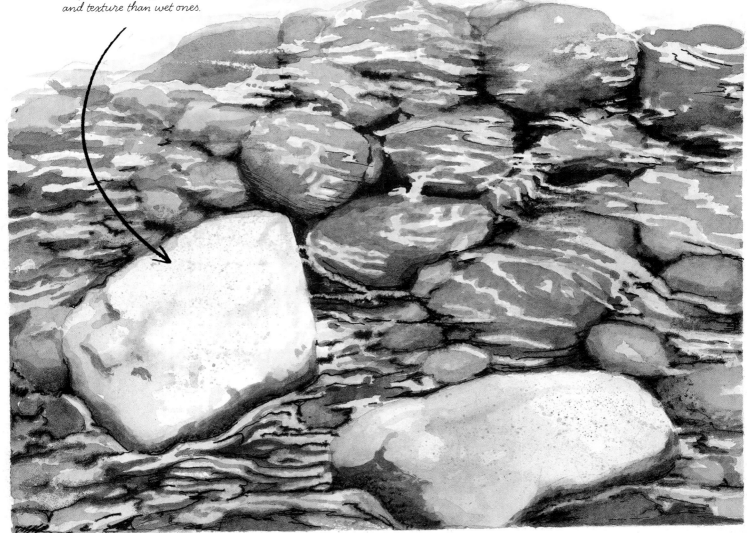

Clear Whitewater

The most important aspect in a whitewater scene, be it raging rapids or gentle logjam riffles, is the white. If too much of the white of the paper is penned or painted out, the water will appear dirty.

Step 1: Start with a pencil sketch, and then add a light watercolor wash to help determine what's what in the scene.

Step 2: Use contour pen strokes to show water movement over obstacles.

Step 3: Add more color.

contour pen strokes (.25 and .35mm)

many pure white, foamy areas

scribble strokes for moss and foliage (.25 and .35mm)

Moss Lemon Yellow + Sap Green + a hint of Cadmium Red

The foliage consists of several values of true or Permanent Green + Sap Green.

Ultramarine Blue mixed with a little Dioxazine Purple + Payne's Gray makes a cool, clean shadow mixture for the whitewater.

In this shallow creek landscape, the still water takes on the color of the sandy creek bottom mingled with the olive reflections of the overhanging trees.

The logs are a range of reddish-browns (Burnt Sienna + Sepia).

The color of the logs can be seen through the clear, cascading water.

Wildwood Creek
Watercolor enhanced with pen and ink
15" × 11" (38m × 28cm)

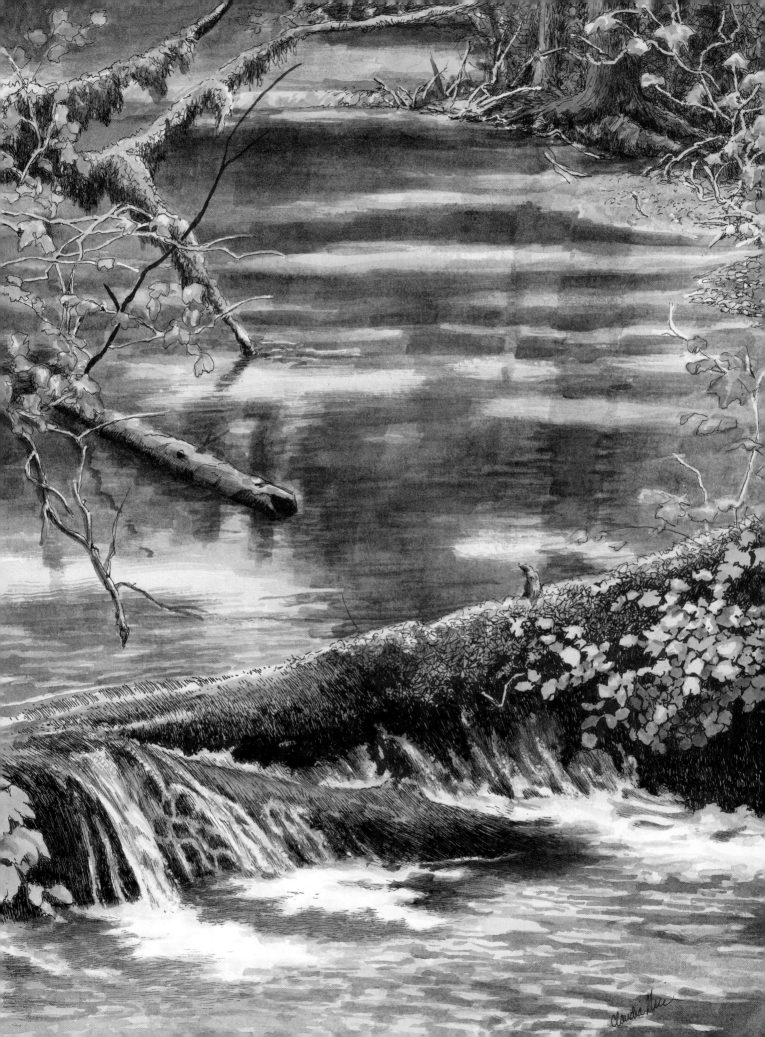

Rapids

A portion of a river where the current runs swiftly and is characterized with turbulent water is referred to as the rapids. Rapids consist of a generous portion of whitewater spray and foam which is best suggested with the white of the paper.

Sap Green Sap Green + Cadmium Red Light Sepia added

Turbulent water often carries sediment that influences its coloration. This chart shows the color mixtures used in this three-step demonstration.

Step 1: Start with a pencil drawing to indicate the larger whitewater areas and the rise and fall of the flow.

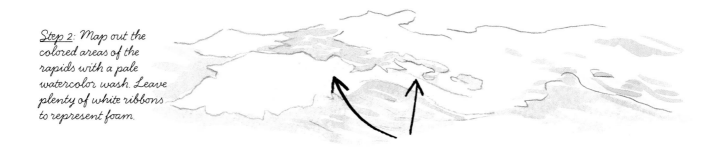

Step 2: Map out the colored areas of the rapids with a pale watercolor wash. Leave plenty of white ribbons to represent foam.

white foam ribbons

Step 3: Erase apparent pencil lines and add shadows using darker versions of the preliminary wash color. Developing the flow of the water is a slow process.

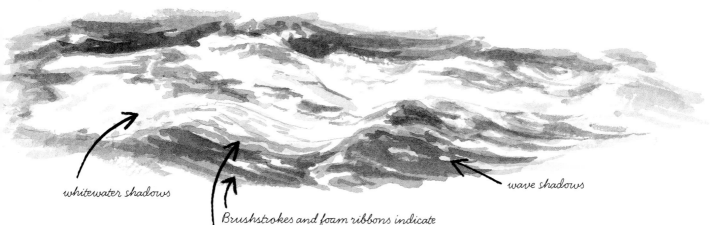

whitewater shadows

Brushstrokes and foam ribbons indicate the rise and fall of the water.

wave shadows

Floodwaters

Flood runoffs carry a heavy amount of mud and debris making them dark and murky.

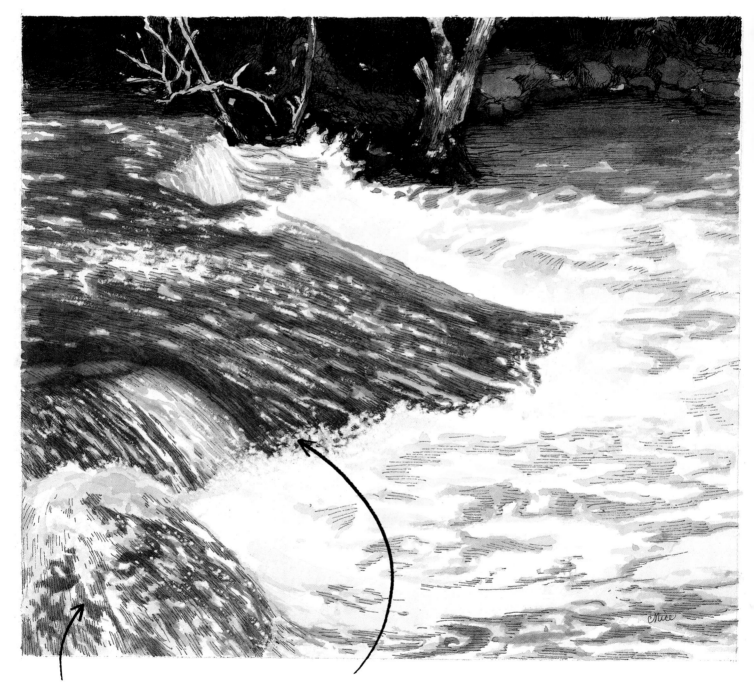

Brown contour pen lines help to portray the swift, turbulent current. Also, black ink scribble lines deepen the tone of the far bank, adding a sense of drama to the scene.

A razor was used to scrape fine spray droplets and tiny reflective highlights into the surging water.

Waterfalls

Unless it's carrying a lot of sediment, falling water consists of white froth and transparent patches that reveal the color of the terrain behind it. Here are three different techniques used to portray the same waterfall.

pen-and-ink sketch (nib sizes .25, .35 and .50mm)

Contour ink lines add a sense of motion to the falling water. Contour lines laid closer together suggest the underlying rock. Scribble lines work well to depict foamy edges.

The foamy areas were marked in pencil and left unpainted. A mixture of Dioxazine Purple muted with New Gamboge and lots of water was used to stroke in the shadows and the transparent portions of the falls. Sepia was added to the mix to indicate the visible sections of rock. To finish the painting, masking fluid was used to protect the white areas.

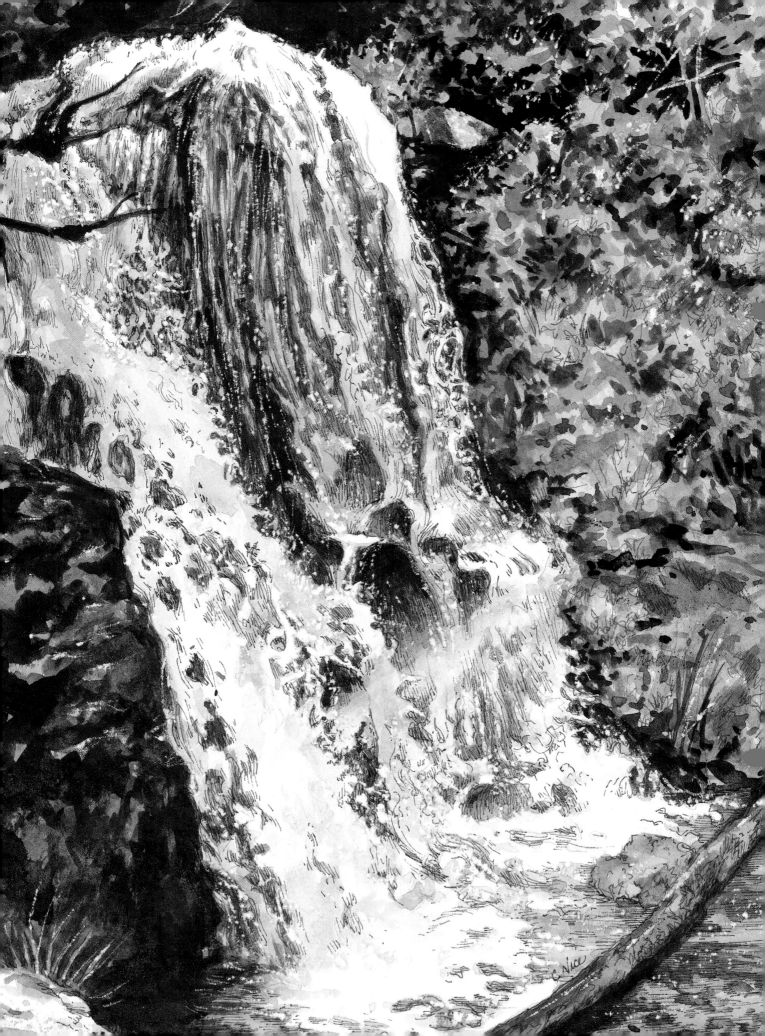

Paint a Waterfall

Here are the steps I took to paint *Rainbow In the Falls*.

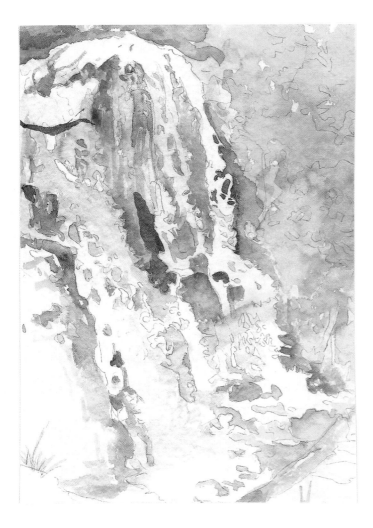

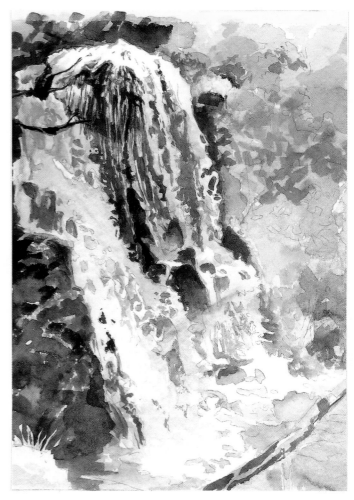

Step 1: Working from a photo, I pencilled in the basic contours. To avoid confusion, I mapped out the shadow and visible rock areas of the falls using a thin wash of Sepia muted with Dioxazine Purple. Basic background shapes and colors were also blocked in using washes of Sap Green mixed with New Gamboge. The rainbow consists of narrow streaks of Quinacridone Rose, Cadmium Red, New Gamboge and Sap Green washes

Step 2: Layering techniques were used to deepen the shadow and rock areas of the falls. Great care was taken to preserve the whitewater portions of the waterfall. The background was further developed by layering in brighter green daubs with a no. 4 round brush. The outer contours of the waterfall were painted using the Sepia + purple mix. Olive greens muted with Sepia were applied to the left bank, and then deeper washes of Sepia were layered on to give the scene a rocky appearance. Burnt Sienna mixes were brushed into the foreground.

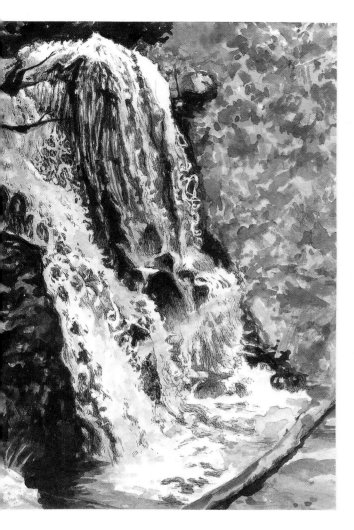

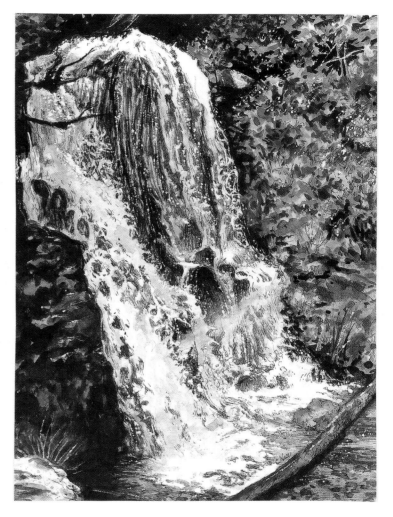

Step 3: I continued to develop the various areas of the painting by layering on daubs and streaks of more intense color and by deepening the shadows. Note that a wash of medial blue muted with the Sepia / purple mix was added to some of the remaining white areas of the falls to shade the foam. During step three, pen-and-ink contour and scribble lines were added to the darker portions of the falls to enhance the motion and shape of the tumbling water. I used a muted purple-brown ink mixed from Sepia, Indigo and Magenta in Rapidograph pens, nib sizes .25mm and .35mm. Dip pens could also be used.

Step 4: Deep shadows were added to the background undergrowth, and finishing touches of color and shadow were placed in the foreground, including patches of moss on the log and the rock above it. Pen work in purple-brown was scribbled here and there for textural effect. The final step was to razor-scrape highlights and droplets into the falls.

Rainbow in the Falls
Watercolor enhanced with pen and ink
11" × 8½" (28cm × 22cm)

97

Waves and Whitecaps

Choppy waves can be compared to a range of little hills with a sunlit side and a shaded side. The shadow is darkest near the crest and lightens as it approaches the trough.

Each of the painted examples below began as a pale wash of blue-green muted with a touch of red-orange. The shaded portions of the waves were darkened by applying consecutive layers of the blue-gray wash, each layer being a little stronger in pigment.

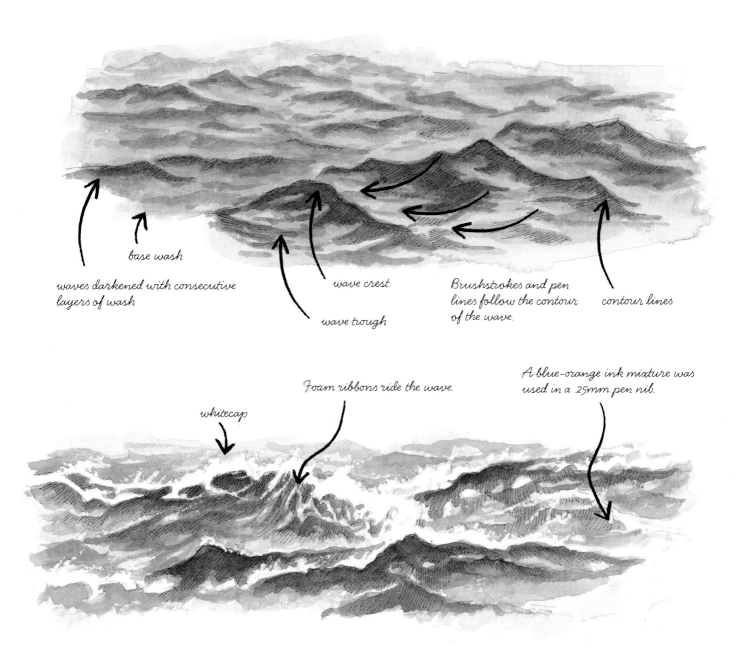

base wash

waves darkened with consecutive layers of wash

wave crest

wave trough

Brushstrokes and pen lines follow the contour of the wave.

contour lines

whitecap

Foam ribbons ride the wave.

A blue-orange ink mixture was used in a .25mm pen nib.

When choppy waves are rough enough to break and foam at their crest, they are called whitecaps. Ribbons of foam often cling to the waves' contours.

Although painted waves can be quite dramatic as simple brushwork, the addition of contour ink lines will accentuate the movement of the water.

Paint a Breaking Wave

When a large wave is pushed into a peak by the wind, tide or shallow ground and proceeds to curl over itself in a descending wall of water, foam and spray, it's referred to as a breaker. Breakers are especially appealing to the artist because of their inherent power, movement and contrasting qualities. When the sunlight shines through them, they are just plain beautiful.

blue-green

various shades of bright blue-gray

red-orange

leave white areas unpainted

Step 1: Pencil in the basic shapes and map out the water areas with a blue-green wash muted with a hint of red-orange.

Step 2: Gradually deepen the color of the wave from the base wash at the crest to a dark blue-gray in the trough. Using a clean, damp brush, blend darker tones into the lighter layer while it is still moist.

Step 3: Finish the breaker by adding foam shadows in light blue-gray and accenting the movement of the wave with blue-gray contour pen strokes.

razor-scratched highlights

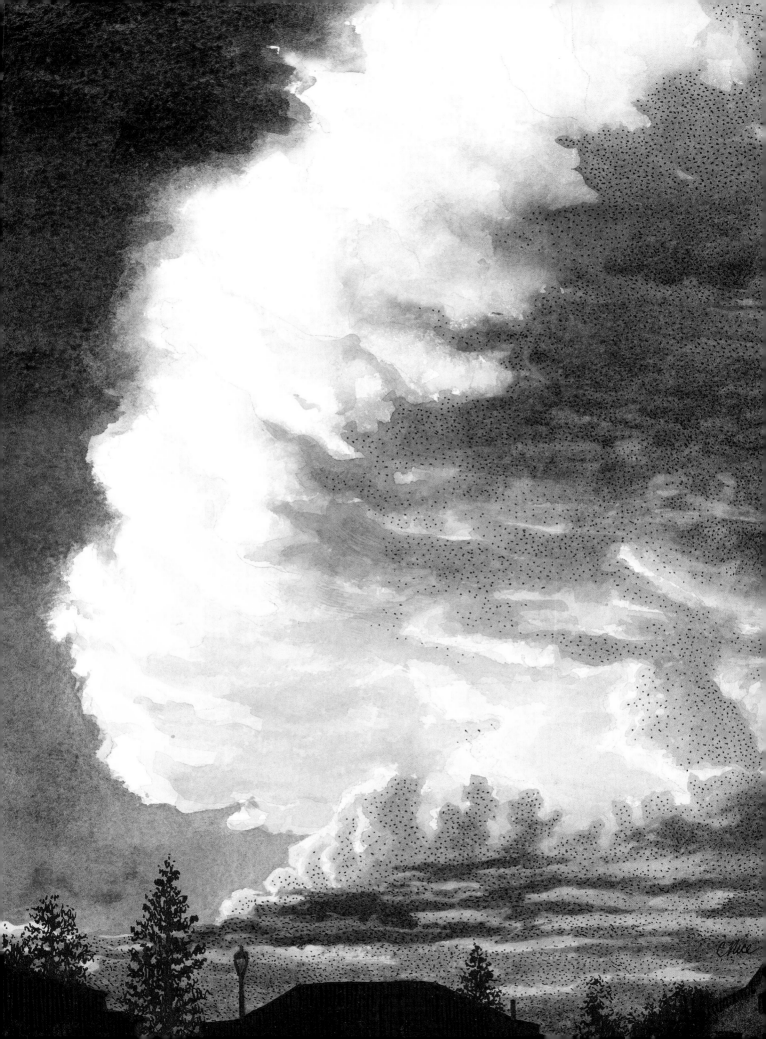

Out in the Weather

Consider the clouds. What do you see floating in the sky or gathered in the memory bank of your mind's eye? Are the cloud formations thin and fragile like cobwebs, or are they gathered into billowy mounds like bleached cotton candy? Perhaps they have cast themselves over the sky like a sodden woolen blanket dripping on the earth. Some are glorious reflectors of light, while others cover the sun, changing noonday to night. Cloudy skies, precipitation in its various forms, and weather-induced lighting conditions are captivating art subjects. Understanding how to express their tenuous qualities with brush and pen is the aim of this chapter.

When wisps of cirrus clouds or fluffy rows of cumulous clouds drift across the background sky in a landscape, the luminosity of watercolor is equal to the task of portraying them. The addition of pen-and-ink lines is not necessary and may detract from the delicate nature of the clouds. On the other hand, when a gathering of clouds becomes the subject of a painting, and the assemblage is bold in nature, suggesting movement, strength and power, pen and ink can be used to enhance the energy of the cloud formation.

Noonday Tempest is an example of a bold cloud composition. It portrays a wall cloud, the type of storm cloud that spawns tornados. I saw this one in person. It was magnificent in its unassailable might. Being in its presence was humbling and scary. Recreating it on paper was an adventure. I used such watercolor techniques as flat wash glazing, damp brush blending, wet-into-wet pigment flows and drybrushing to achieve the final result. Using these techniques to create clouds is demonstrated for you within the pages of this chapter. To emphasize its ominous, tempestuous nature, I overlaid the darker areas of the cloud formation with black pen stippling (.35mm nib) and used the pen to enhance the silhouettes of the houses and trees in the foreground.

Noonday Tempest
Watercolor embellished with pen and ink
11" × 8½" (28cm × 22cm)

How to Paint a Flat Wash

Flat washes work well to depict pristine skies. Here's how to lay a smooth one. To prepare, mix a large quantity of fluid color. Tape the paper to a backing board and moisten the surface, blotting off any standing water. Raise the top edge of the board 30 degrees to encourage the downward flow of paint.

Step 1: Fill a flat brush with color and stroke it horizontally across the top of the paper using minimal strokes.

Step 2: Apply the second row of paint directly below the first. Overlap the rows, absorbing the gathering of paint at the bottom of row one and moving it along.

Step 3: Continue in this manner, overlapping each row. After the final stroke, wick up the remaining bead of paint and lay the board flat to dry. Do not apply additional smoothing strokes.

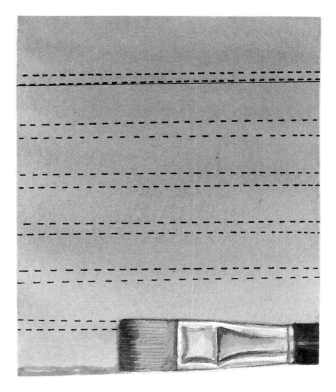

Lightly pressing a crumpled facial tissue into a wet flat wash creates delicate cirrus clouds.

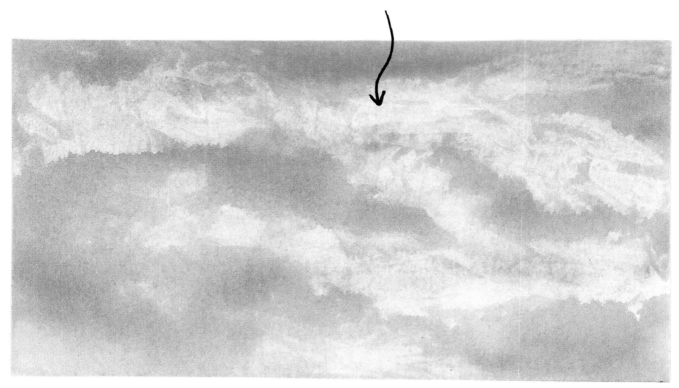

Layered Clouds

Glazing, the application of thin layers of paint one on top of the other, is a controlled method of creating fluffy cumulus clouds. Each coat must dry before the next glaze layer is added.

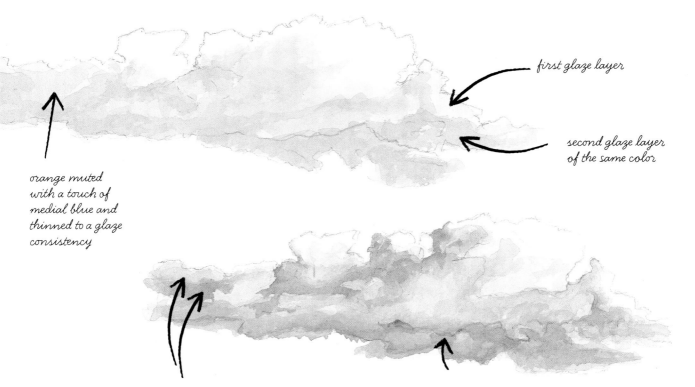

first glaze layer

second glaze layer of the same color

orange muted with a touch of medial blue and thinned to a glaze consistency

The third and fourth glaze layers are medial blue muted with a touch of orange.

The edge of a moist glaze layer can be softened by stroking it with a clean, damp brush. Clean and blot the brush often.

a flat wash of medial blue

layered washes of Ultramarine Blue muted with orange

Stormy Weather

Freestyle storm clouds are among the most fun to paint . . . you just mix up a range of grays, pick up a flat brush and see where your imagination will take you.

The cloud scene below began with a pale patch of medial blue applied as a flat wash. When it was dry, I went wild with wet-into-wet applications.

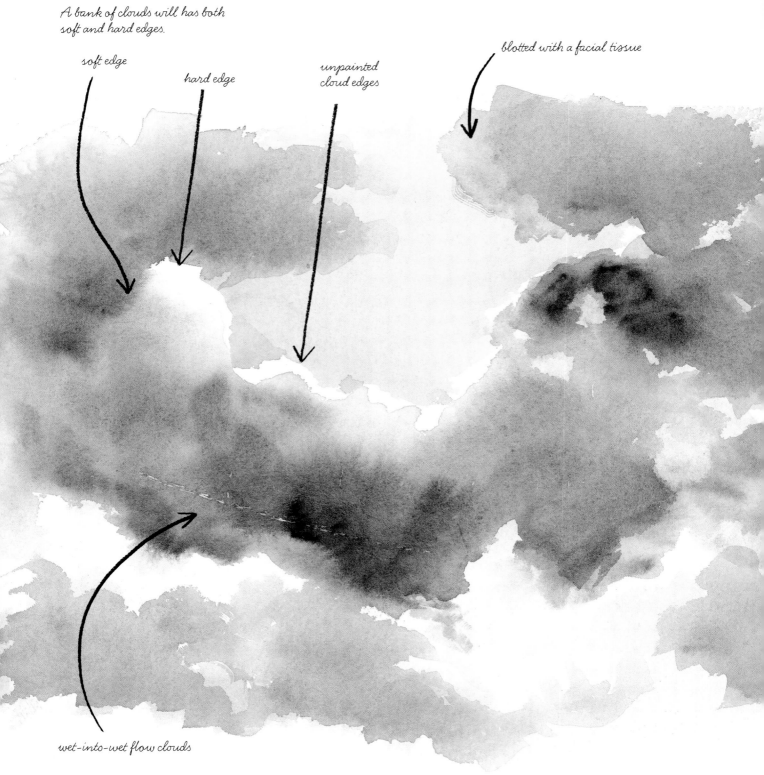

A bank of clouds will has both soft and hard edges.

soft edge

hard edge

unpainted cloud edges

blotted with a facial tissue

wet-into-wet flow clouds

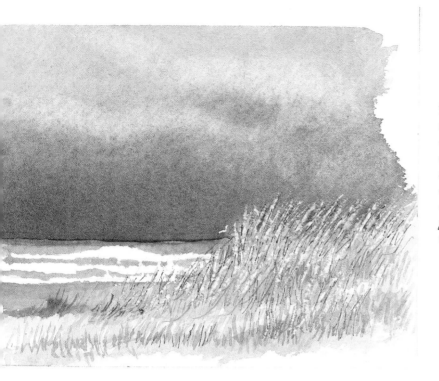

Thick stormy skies usually make poor lighting conditions and dreary paintings. However, this miniature scene shows a striking exception... a sunlit foreground against a dark cloud bank. The threat of the approaching storm adds excitement to the scene as well as contrast. The dark background was laid into place as a heavily pigmented flat wash, then blotted to lighten the top portion.

Rays of sunlight breaking through a tempest sky are quite dramatic. Here the sunray columns were lifted out of a moist (not wet) flat wash using a damp flat brush of the appropriate width. A band of paper-white sun glare was left at the top of the ray columns to suggest their source. Highlights were scraped in.

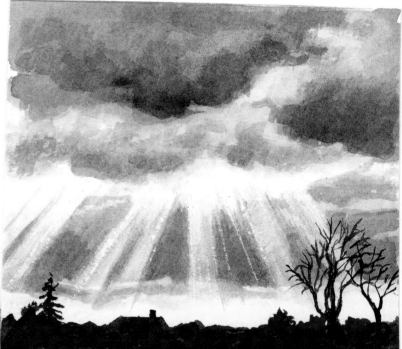

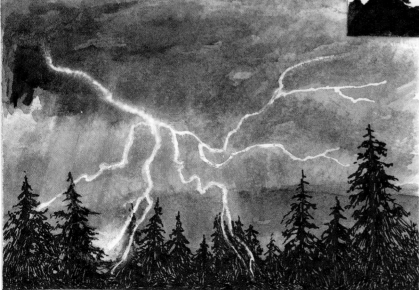

The lightning strike depicted was masked into place using a narrow-tipped application bottle. The clouds were painted in using wet-into-wet techniques. The edges of the lightening bolt were razor-scraped to add a soft glow.

105

Fog and Mist

Mist adds intrigue to a painting, but a heavy fog can obliterate the scene.

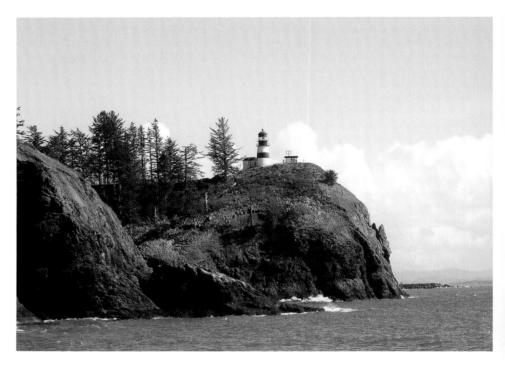

This photograph shows a winter view of the cliffs marking the mouth of the Columbia River, the spot where it enters the Pacific Ocean. It's a popular scene among artists. I took the photo and you have my permission to paint from it.

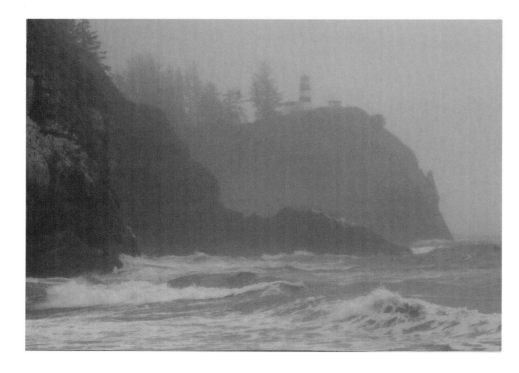

This photograph shows the same scene in heavy fog. The thick fog bank blocks out most of the light. As you can see, visibility is very poor. The cliffs appear flattened and devoid of texture. Without sufficient light, colors are muted into drab tones of gray. Only slight value changes suggest the forms being viewed. This would not make an effective painting. To paint fog you must thin it and allow a little light to shine through.

This miniature watercolor painting is a combination of fog and sunlight. By using lighter, brighter grays and touches of color, the scene looks less drab and dreary. The seascape was painted in a series of thin washes or glazes. Each glaze was allowed to dry before the next one was added, leaving a bit of the previous layer to show through. Misty areas were blotted with a tissue while the base wash was still moist. Pen work would look too heavy on a painting this size. Stippling could enhance the cliffs on a larger format.

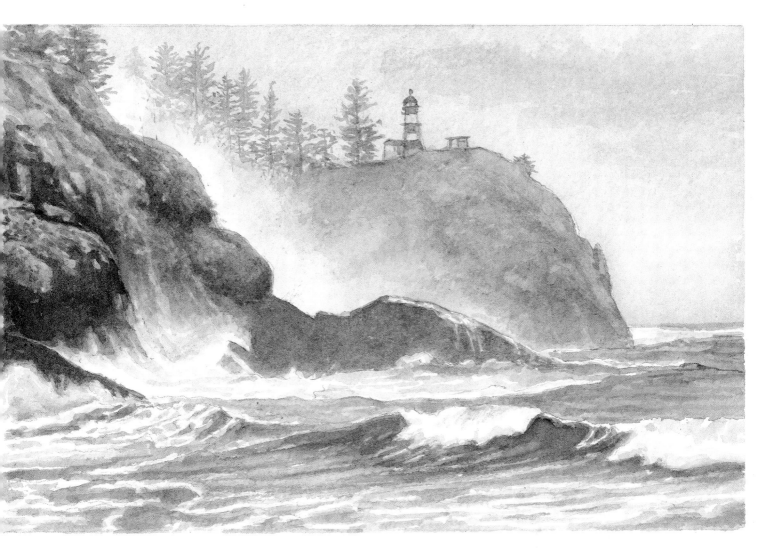

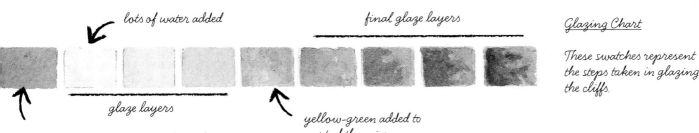

lots of water added

final glaze layers

Glazing Chart

These swatches represent the steps taken in glazing the cliffs.

glaze layers

yellow-green added to part of the mix

Basic color mix is Dioxazine Purple + yellow + a hint of Payne's Gray.

Snow

Heavy snow clouds filter out the natural light and a veil of falling snow obscures visibility. The result is gray and dreary. In this painting, I've allowed an off-scene break in the clouds, and the sun is shining through enough to highlight the gentle snowfall. Before I started painting, masking fluid in a bottle applicator was applied to protect the individual snowflakes and the snow on the limbs and underbrush.

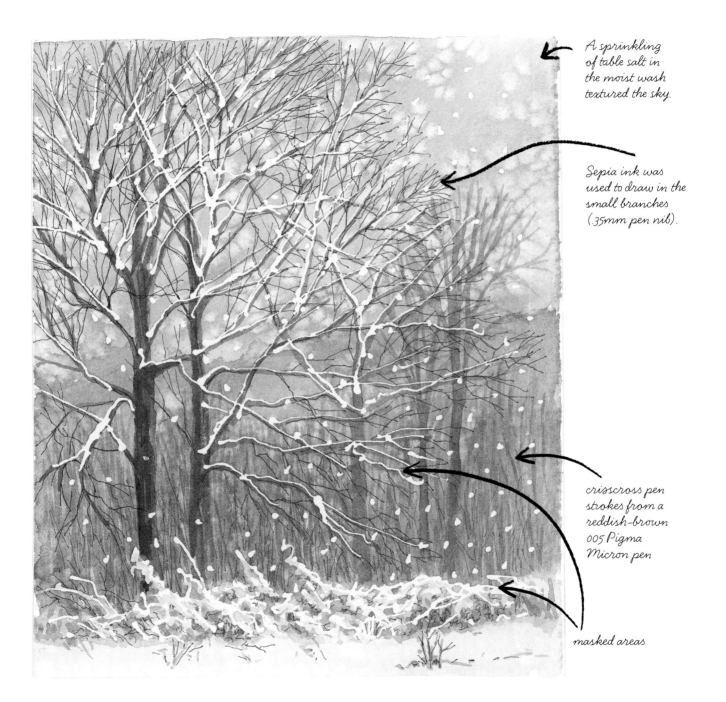

A sprinkling of table salt in the moist wash textured the sky.

Sepia ink was used to draw in the small branches (.35mm pen nib).

crisscross pen strokes from a reddish-brown 005 Pigma Micron pen

masked areas

In bright sunlight, shadows cast across the surface of the snow are blue or bluish gray.

Masking fluid was used to protect the grass stems.

Brown pen and ink was used to draw the small branches.

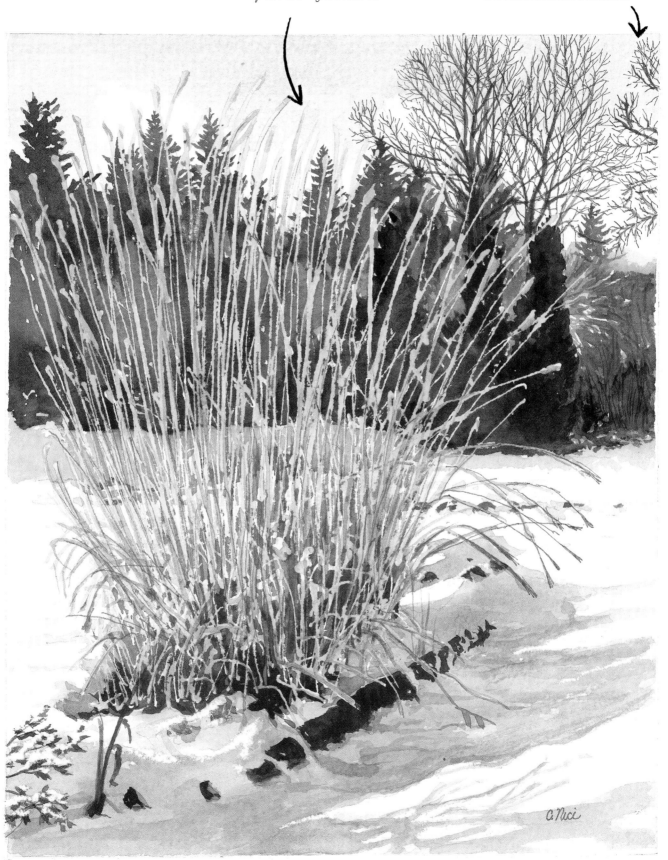

a. Nici

Paint a Simple Sunset

The foundation of this sunset painting is a varied flat wash in which the color changes as it's laid down, working from the horizon toward the top.

Step 1: Begin by cutting long, narrow cloud shapes and a half-round sun out of masking tape. Stick them firmly in place.

Step 2: Mix separate paint puddles for each color in the sky. Red-orange slightly muted by adding a hint of medial blue is the base mix from which most of the other mixtures are created. Refer to the chart.

Step 3: Before applying the paint, wet the sky area, let it sit a moment, then blot it. Slant the paper so the sky is at the low end.

Step 4: Working quickly, paint a yellow halo around the sun. Rinse and blot the flat brush and then lay down the base wash, allowing it to mingle with the yellow.

Step 5: Paint your way through the other tones, rinsing the brush before blending in each new color.

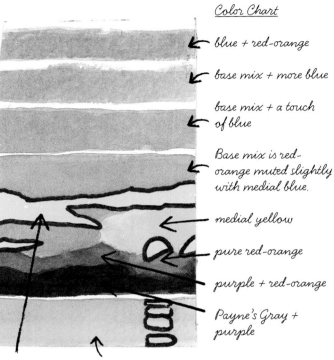

Color Chart

blue + red-orange

base mix + more blue

base mix + a touch of blue

Base mix is red-orange muted slightly with medial blue.

medial yellow

pure red-orange

purple + red-orange

Payne's Gray + purple

masking tape cutouts

base mix + water

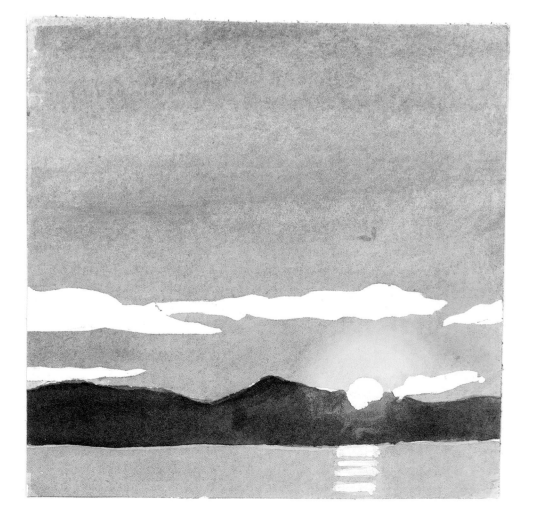

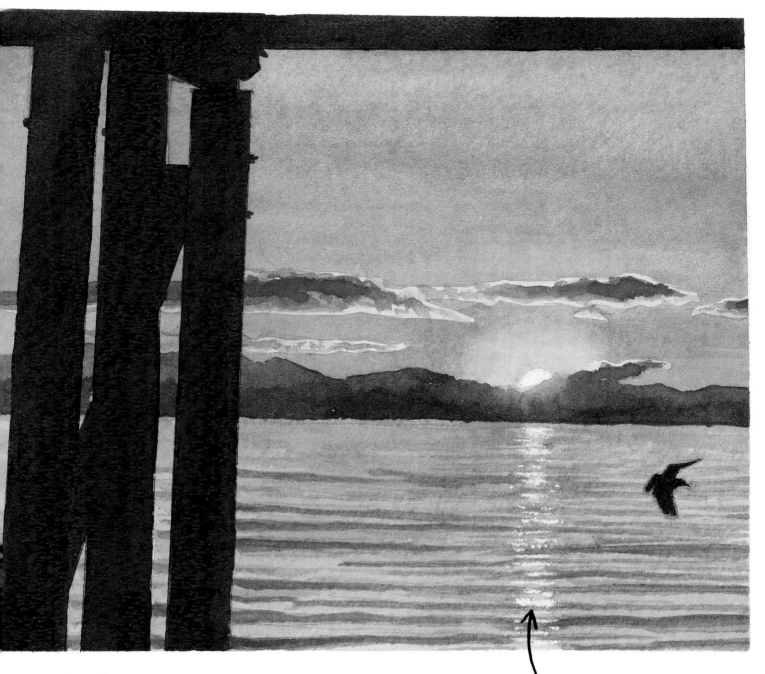

razor scrapes

Paint the sea with a pale version of the orange base mix.
Leave or mask out a white area for the sun reflection. Let
the washes dry. Remove the masking.

The distant hills can now be painted beginning with the
red-orange glare below the sun. Let the purple of the hills
charge into it to form rays.

The clouds are painted medial yellow and allowed to
dry. A medium, then a dark mixture of red-orange plus
purple is layered in the center of the clouds.

Yellow is streaked through the reflection lines in the water,
followed by blue horizontal wave lines. Paint the silhou-
ettes with a purple / Payne's Gray mix and stipple them
with pen and ink.

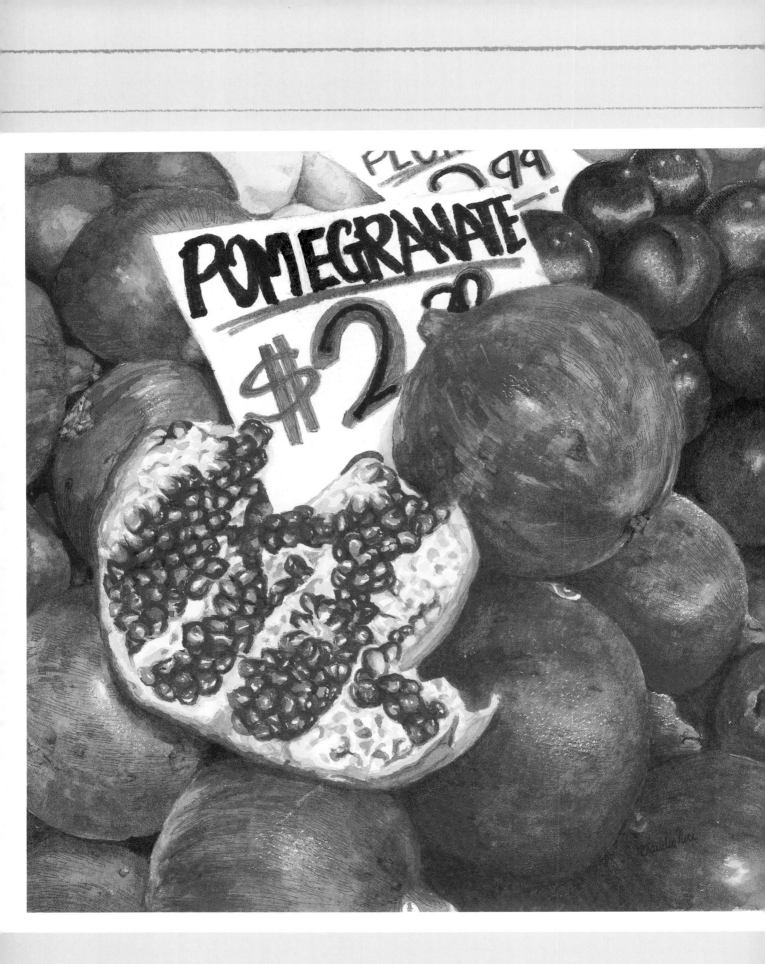

Familiar Arrangements

A still life is an arrangement of inanimate objects. The fact that the objects have no power to move on their own has definite appeal to the artist who is then given all the time needed to experiment with different setups and lighting conditions. The artist is allowed the luxury of studying the subject in detail, analyzing the various shapes, colors, textures and edge definitions, before picking up the pencil, pen or brush.

I personally accept a good still-life setup as a challenge. I love to see how close I can come in recreating the various elements as they appear in real life. It hones my observation skills, exercises my painting skills, kick-starts my creativity and tries my patience. However, realism is just one approach to still-life depiction. The impressionist interprets the setup loosely, using bits of color and bold brushstokes to describe the scene, while the abstract artist may simply use the still-life arrangement as a catalyst to trigger the imagination and creativity, resulting in a painting far afield from the original setup. No matter what style you choose to explore, still-life painting can be a worthwhile endeavor, providing the opportunity to develop artistic skills in the comfort of your own home or studio at a pace you determine.

A still-life setup need not be limited to a floral arrangement or a bowl of fruit. There is a whole world of inanimate objects out there. Consider household objects, antique items, tools, toys and bits of nature (stones, seashells, driftwood, etc.) as possibilities to get you started. Keep your eyes open for interesting objects as you move through your daily life.

I encountered the pomegranate setup at a busy outdoor market. I liked the bright eye-catching colors and the hand-written signage that stretched diagonally into the scene to share the focal point with the jewel-like pomegranate seeds. The only drawback was my inability to transport it to my studio. I had to make due with the purchase of a couple pieces of fruit and several clear reference photos . . . not ideal, but it sufficed. Subtle texturing with brown ink and a 005 red Pigma Micron pen helped me re-create the distinctive look of the pomegranate skin, while tiny flicks of a razor suggested its grainy highlights. Just for fun, permanent markers were used to re-create the tags in the same manner in which they had originally been written. Although it's not your typical still life, it was a fun project and helped me develop several new techniques.

Market Jewels
Watercolor embellished with pen and ink
8" × 8" (20cm × 20cm)

Glazed Pottery

Glazed, shiny surfaces show strong highlights on the contours closest to the light source. Rounded shapes have blended form shadows, the values changing gradually. There may be reflected colors and shapes cast from other objects. Watercolor glazes work well to suggest these qualities. Let's break down how to paint a ceramic pitcher.

warm yellow-orange

Step 1: Indicate the areas of strong highlight and leave them unpainted. Begin with the lightest color and let it dry completely.

Step 2: Apply the midtone hues in thin glazes of color, letting each dry completely before adding the next. Blend the edges while still moist, using a clean, damp brush.

Burnt Sienna + mix

Burnt Sienna + orange

Step 3: Glaze in the deep form shadows, blending the edges where appropriate. Abrupt edges form hard-edged shadows.

Step 4: In pottery pieces seen up close, dry-brushing or subtle contour pen strokes work well to add a bit of texture.

cast shadows

brown ink contour lines

Grandma's Pitcher
Watercolor enhanced with pen and ink
9" × 8" (23cm × 20cm)

On the highly polished surfaces of fine ceramics, the texture of ink work may be too harsh. However, it can serve nicely to enhance decorative embellishments as seen in this pitcher painting. Rowney Blue 119 ink was used. The form shadows are glazes of blue plus orange.

Silver and Brass

Polished metallic surfaces catch and play with the light. Shapes and colors cast from nearby objects shimmer reflectively over the contours in a distorted funhouse mirror likeness. Highlights flash white and shadows appear very dark with a wide range of values in between. The local color of silver and brass can be warm or cool depending on the lighting and the hue of the surrounding field. The callouts placed on this and the following page will show you some simple basecolor mixtures. The silver plate consists of glazed layers of cool gray. Add more orange to warm the mix.

Observation is the key to the correct placement of reflected shapes, colors and values, all of which can appear quite bizarre. It is essential to work from life or a quality reference photo.

Reference Photo

light-value base wash

highlights left unpainted

midtone values added in glazed layers

darkest values added

pen-and-ink embellishment

medial blue + orange in glazed layers

black ink

The brass ship's lantern painted consists of both warm and cool tones in its range of local color. The paint was applied in layered glazes following the value patterns observed in the reference photo.

Rounded metal surfaces have softly blended form shadows, but the cast shadows and reflections may vary greatly in the hardness of their edges.

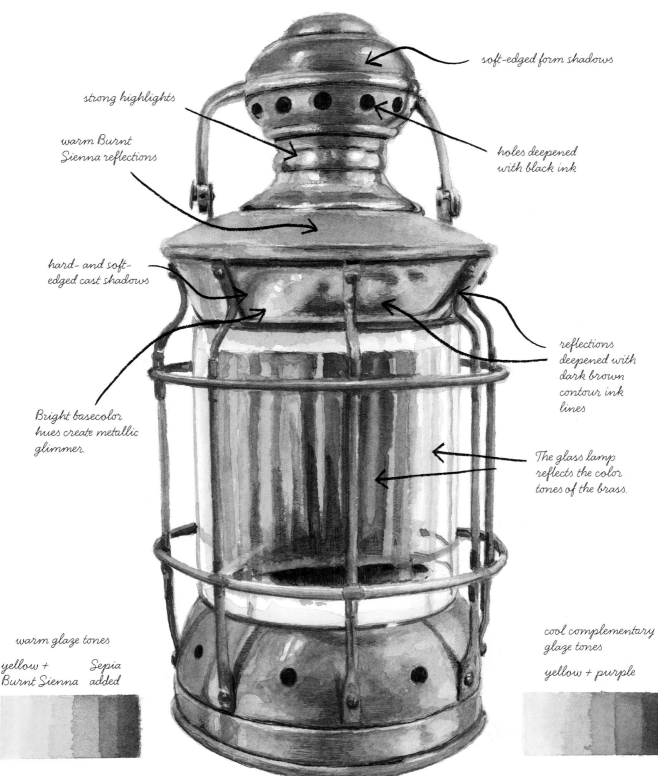

soft-edged form shadows

strong highlights

warm Burnt Sienna reflections

holes deepened with black ink

hard- and soft-edged cast shadows

reflections deepened with dark brown contour ink lines

Bright basecolor hues create metallic glimmer.

The glass lamp reflects the color tones of the brass.

warm glaze tones

yellow + Burnt Sienna Sepia added

cool complementary glaze tones

yellow + purple

Portraying Glass Objects

Glass is a whimsical chameleon, changing its appearance with every light beam, color, shape or shadow that reflects off its surface. To portray it, the artist needs to consider not only the shape and local color of the glass object, but also the color and shape of the things behind it, inside it, beside it and in front of it. To add to the confusion, images seen through curved glass or reflected off its surface will be distorted. Considering all of these factors, I find it helpful to work from an enlarged photograph as well as the actual setup, especially if I intend to portray the glass object in a realistic manner. Below is a photograph of a still-life composition I arranged. I've painted the pitcher for you step by step.

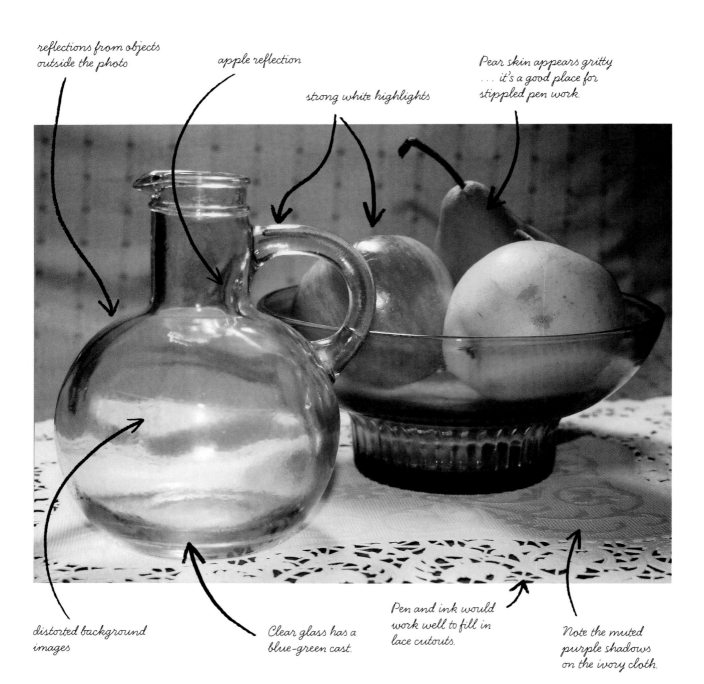

reflections from objects
outside the photo

apple reflection

strong white highlights

Pear skin appears gritty
... it's a good place for
stippled pen work.

distorted background
images

Clear glass has a
blue-green cast.

Pen and ink would
work well to fill in
lace cutouts.

Note the muted
purple shadows
on the ivory cloth.

Step 1: My portrayal of a glass pitcher began with a detailed drawing outlining the highlights, shapes and colored areas that I saw as I studied the model. To avoid confusion, pale watercolor washes were used to map out the various areas. Highlights and small patches of color were left unpainted.

Step 2: I used the same colored washes to deepen the hue according to the light play I observed. Edges were blended or left abrupt, depending on how they appeared in the model. Small colored areas were added.

Step 3: Washes containing more pigment were placed in the appropriate areas to deepen the shadows.

abrupt edge

blended edge

Deep contour shadows follow the shape of the pitcher.

Step 4: The darkest shadows were added last. Their deep value tones bring the glass pitcher out of obscurity by describing its round contours. Adding the background clarifies the placement of the colored areas within the form.

119

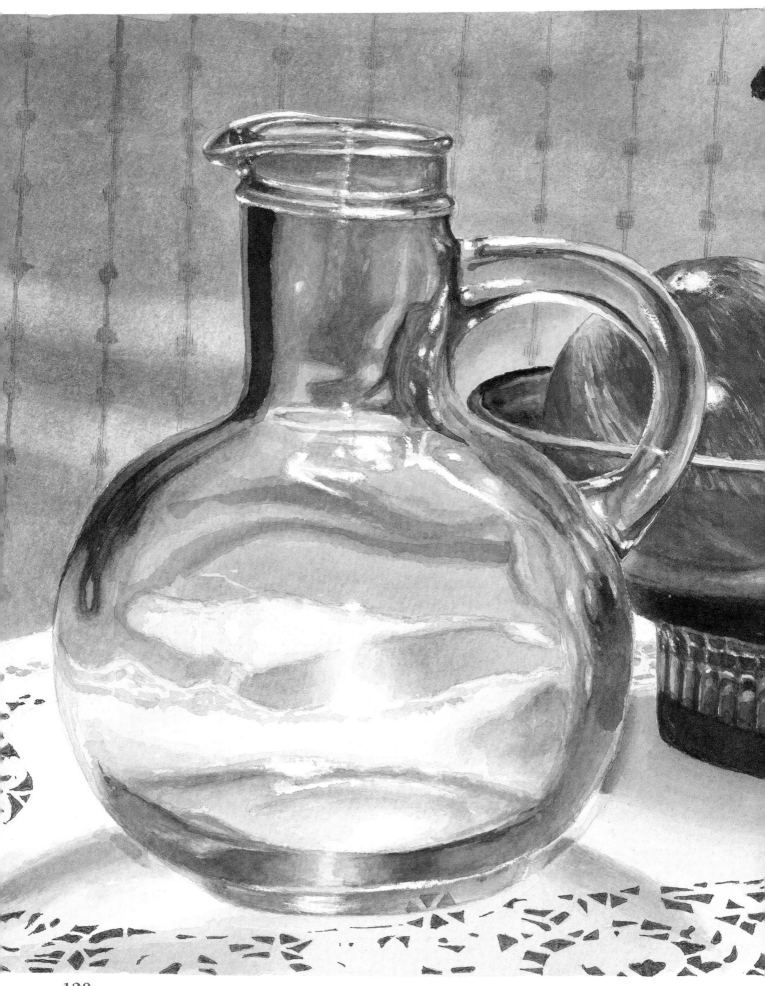

Two shades of brown ink were used to fill in holes in the lace cloth and to texture the skin of the pear with stippling. Dark blue-violet ink and parallel lines created the pattern in the background drapery. Because of its boldness, pen-and-ink lines would have detracted from the transparent quality of the glass and the smooth, shiny skin of the apples, so these objects were completed using only layered watercolor washes.

Claudia Nice

Glass Pitcher
Watercolor enhanced with pen and ink
11" × 15" (28cm × 38cm)

Paint a Floral Arrangement

This still-life painting began as a quick and loose rendering in which little attention was paid to detail. With the exception of the flower blossoms, blocked in using pale pinkish washes, the other areas were painted in the color and value most prevalent in each.

The still life looks close to complete after the initial paint is stroked in place. With a little more color and shade work given to the flowers and large shell, it would make a lovely loose-fitting style painting.

Step 1: Overlapping leaves that were similar in tone and hue were grouped together and painted as one unit. A grouping of seashells and a block of petrified wood provided a balance of weight and value in the lower half of the scene.

Step 2: Depending on how much detail and shade work is added, the still life can move from a loose impressionistic style toward realism. I fussed with this painting quite a bit, even adding a third shell and background drapery.

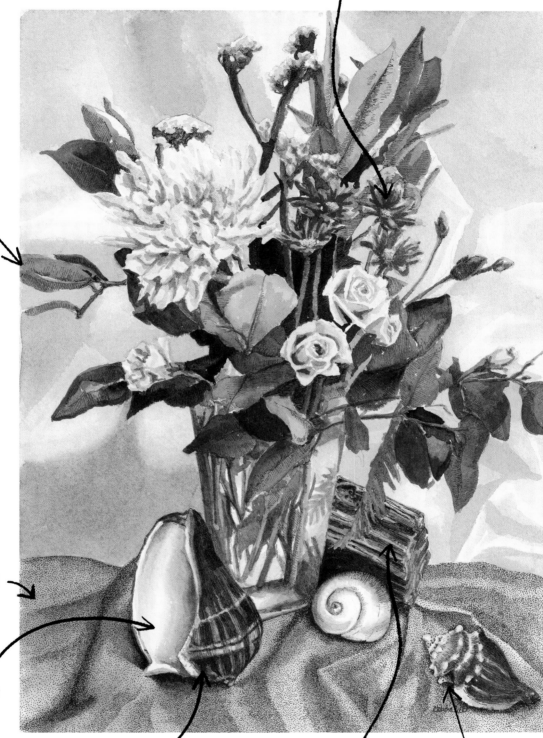

flower centers stippled with
green ink (.25mm)

parallel and
contour lines
(brown-green
ink mixture
with a .35mm
nib)

brownish-green
stippling (.35mm)

no ink texturing
inside the shell

contour line strokes in
both brown and black
inks (.35mm and .25mm)

brown and black
wavy lines

reddish-brown
contour lines
(.25mm)

Step 3: In the finished painting, pen and colored ink
were stroked over the dry watercolor paint to develop the
various textures. To maintain the delicate nature of the
flower blossoms and background drapery, pen work was
not used in those areas.

Flowers and Seashells
Watercolor enhanced with pen and ink
15" × 11" (38xcm × 28cm)

Index

 Other fine North Light products are available from your
favorite bookstore, art supply store or online supplier.
Visit our website at fwmedia.com.

16 15 14 13 5 4 3 2

DISTRIBUTED IN CANADA BY FRASER DIRECT
100 Armstrong Avenue
Georgetown, ON, Canada L7G 5S4
Tel: (905) 877-4411

DISTRIBUTED IN THE U.K. AND EUROPE
BY F&W MEDIA INTERNATIONAL LTD
Brunel House, Forde Close, Newton Abbot, TQ12 4PU, UK
Tel: (+44) 1626 323200, Fax: (+44) 1626 323319
Email: enquiries@fwmedia.com

DISTRIBUTED IN AUSTRALIA BY CAPRICORN LINK
P.O. Box 704, S. Windsor NSW, 2756 Australia
Tel: (02) 4577-3555

Edited by Sarah Laichas
Designed by Wendy Dunning
Production coordinated by Mark Griffin

About the Author

Claudia Nice is a native of the Pacific Northwest and a
self-taught artist who developed her realistic art style
by sketching from nature. She is a multimedia artist,
but prefers pen, ink and watercolor when working
in the field. Claudia has been an art consultant and
instructor for Koh-I-Noor/Rapidograph and Grum-
bacher. She represents the United States as a mem-
ber of the advisory panel for The Society of All Artists
in Great Britain.

Claudia has traveled internationally conducting
workshops, seminars and demonstrations at schools,
clubs, shops and trade shows. She operates her own
teaching studio, Brightwood Studio, in the beautiful
Cascade wilderness near Mt. Hood, Oregon. Her oils,
watercolors and ink drawings can be found in private
collections nationally and internationally.

Claudia has authored more than twenty success-
ful art instruction books. Her books for North Light
include *Sketching Your Favorite Subjects in Pen & Ink*,
Creating Textures in Pen & Ink with Watercolor, *How
to Keep a Sketchbook Journal*, *Down By the Sea with
Brush and Pen*, and *How to See, How to Draw* pub-
lished in 2010.

When not involved with her art career, Claudia
enjoys gardening, hiking and horseback riding in the
wilderness behind her home on Mt. Hood. Visit her
website at brightwoodstudio.com.

Metric Conversion Chart		
To convert	to	multiply by
Inches	Centimeters	2.54
Centimeters	Inches	0.4
Feet	Centimeters	30.5
Centimeters	Feet	0.03
Yards	Meters	0.9
Meters	Yards	1.1

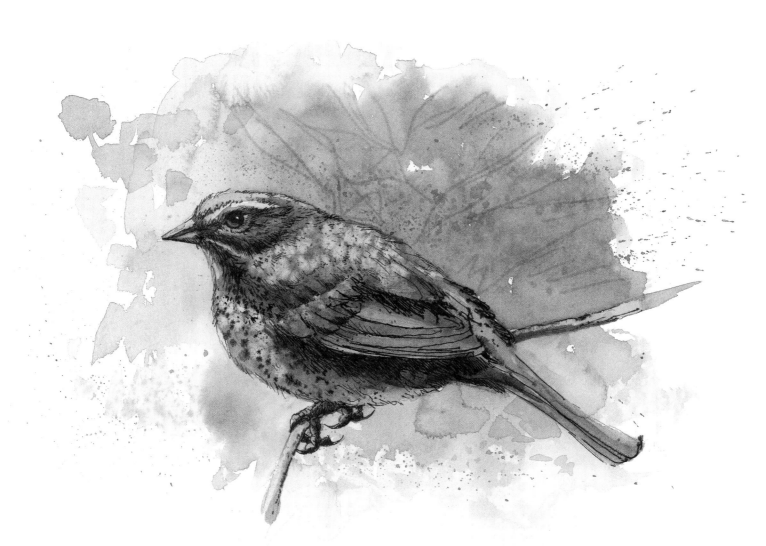

Acknowledgments

The beauty and grandeur of nature can only be copied creatively. The ultimate artistic genius lays with He who created the original design and brought it to life. I humbly acknowledge the work of my Lord.

Ideas. Instruction. Inspiration.

Receive FREE downloadable bonus materials when you sign up for our free newsletter at artistsnetwork.com/Newsletter_Thanks.

Find the latest issues of *The Artist's Magazine* on news-stands, or visit artistsnetwork.com.

Visit artistsnetwork.com and get Jen's North Light Picks!

Get free step-by-step demonstrations along with reviews of the latest books, videos and down-loads from Jennifer Lepore, Senior Editor and Online Education Manager at North Light Books.

Get involved

Learn from the experts. Join the conversation on